Beginner's Guide to
CALLIGRAPHY

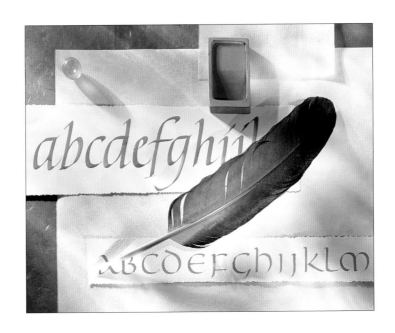

FGh

QRST

Beginner's Guide to
CALLIGRAPHY

A Simple Three-Stage Guide
to Perfect Letter Art

Janet Mehigan
and
Mary Noble

CHARTWELL
BOOKS, INC.

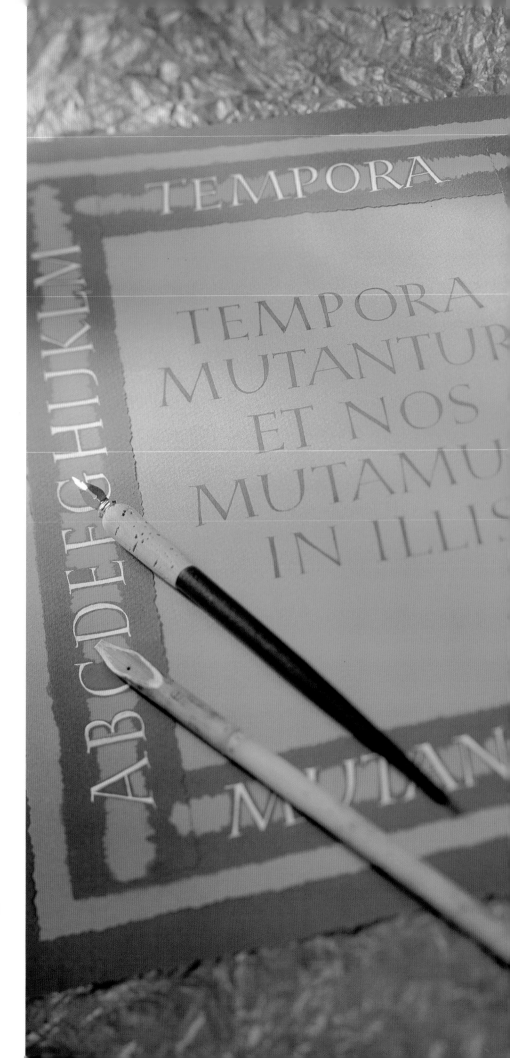

Published by Chartwell Books
A Division of Book Sales, Inc.
114 Northfield Avenue
Edison, New Jersey 08837, USA

ISBN 0-7858-1934-7

QUAR.ABB

Conceived, designed, and produced
by Quarto Publishing plc
The Old Brewery
6 Blundell Street
London N7 9BH

Editor Marnie Haslam
Art Editor Francis Cawley
Assistant Art Director Penny Cobb
Copy Editor Kathy Gemmell
Designer Jennie Dooge,
 Julie Francis
Photographer Martin Norris
Indexer Dorothy Frame
Art Director Moira Clinch
Publisher Piers Spence

Manufactured by Regent Publishing
Services Ltd, Hong Kong.
Printed by SNP Leefung China.

CONTENTS

HOW TO USE THIS BOOK

Calligraphy is fine penmanship, the art of 'beautiful writing'. Successful calligraphy requires a good understanding of letter form. Here each letter style is taught in three simple stages designed for even the most inexperienced beginner. Step-by-step you will learn all the techniques needed to make beautiful calligraphy.

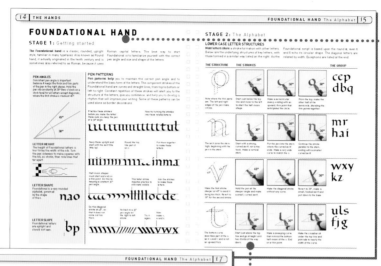

STAGE 1:
Getting started

- Learn the basic rules of correct pen angles and letter height.
- Understand letter angle or slope.
- Practice each pen pattern to help maintain constant pen angles and to familiarize yourself with each letter shape.

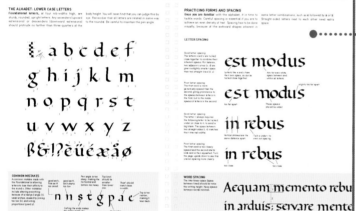

STAGE 2:
Understanding letter structures

- Learn step-by-step the key letter shapes.
- Practice these letters in their family groups.
- A special sheet with ruled lines is provided for practicing each letter style.
- Use layout paper over the practice sheets so you can re-use your practice sheet.
- Look carefully at the Mistakes Panel to ensure that your letters are correct.
- Practice letter and word spacing, writing words, and sentences.

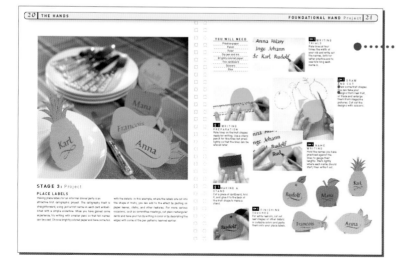

STAGE 3:
Projects

- Use your new calligraphy skills to create a project with each letter style.
- Check your materials and equipment list before you start.
- Approach your projects with confidence as you follow the step-by-step instructions.
- As your knowledge increases, try different pen sizes and experiment with different paint and paper colors.

STAGE 4: Enjoy Calligraphy!

MATERIALS & EQUIPMENT

The increasing popularity of calligraphy has brought with it a huge range of writing tools and materials. The variety may seem confusing at first, but a basic beginner's kit can be simple and inexpensive to assemble. The minimum items that you need for starting are listed below.

ESSENTIAL ITEMS

1 Blotting paper: Use to pad your board, as a guard sheet to protect your writing paper, and to blot ink.

2 Dip pens: Dip pens consist of a handle and a range of differently-sized nibs. Some nibs have integrated reservoirs, others have separate slip-on reservoirs.

3 Pencils, HB and 2H: The harder pencil (2H) stays sharp longer, but an HB is easier to erase later.

4 Eraser: A soft eraser is best; a hard eraser will mark the paper.

5 Pencil sharpener: You must keep your pencils sharp.

6 Masking tape: Use tape to secure the blotting paper pad, and to attach paper when you use a T square.

7 Ruler: A transparent ruler with clear markings is best for measuring; a metal-edged ruler is best for cutting.

8 Drawing board, around 30 in x 24 in (75 cm x 60 cm): It is important to write on a sloped surface to avoid blots and backache. Some boards come with supporting feet or hinges, or you can improvise with a piece of wood.

9 T square: Use a T square in conjunction with your board and a triangle for ruling.

TIPS TO CONSERVE YOUR EQUIPMENT

Old toothbrush: This is an essential tool for cleaning nibs after use.

Water pot: You will need this to dilute inks and paints, and to clean pens and brushes.

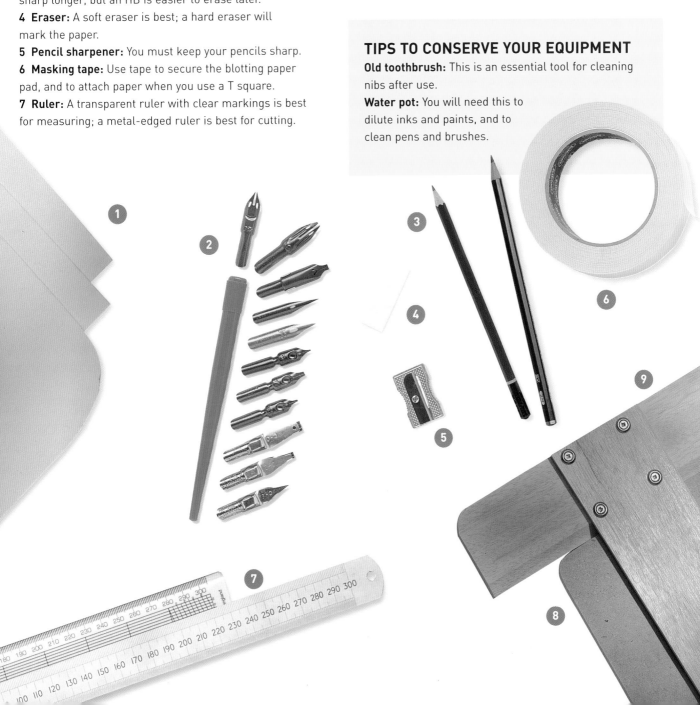

ADDITIONAL MATERIALS

On this page you will find many additional materials that are commonly used in creating a variety of calligraphy projects. You may find these useful to have on hand as you begin to experiment with different ways of presenting your new calligraphy skills.

1 Protractor: This helps to measure pen angles.

2 Scissors: For cutting, of course!

3 Craft knife: Use for sharpening pencils and for cutting paper (with a metal-edged ruler).

4 Fountain pens: These are good for the beginner, and come in a range of nib sizes with the ink in a cartridge. Changing color involves more washing out than with a dip pen.

5 Felt tip pens: These are convenient and come in various sizes and colors. They will eventually lose their sharpness and the colors are not lightfast.

6 Large poster pens: These come wider than most pen nib sets, and are ideal for display work.

7 Paintbrushes: Use an old brush for mixing and feeding the nib, and an artists' quality brush for painting areas of color.

8 Glue stick: Look for a glue with which you can reposition glued articles — this is ideal for trial layouts.

9 Mixing dishes, with several sections: Use these for mixing paints to obtain many colors.

10 Set square: This is useful for drawing right angles and ruling margins.

COLOR

All artistic media can be used in calligraphy: gouache, inks, watercolor, acrylic paints and inks, pastels, and pencils. They can often be used in combination and, with practice, different effects can be achieved. When using colors in any media, it is advisable to begin with six colors: two reds, two blues, and two yellows. This represents two of each of the three primary colors — red, blue, and yellow.

11 Watercolor pans: Watercolor is useful for painted illustrations or for background washes.

12 Calligraphy inks: These come in black and colors. Acrylic inks are ideal for background color. The ideal brushes for painting are sable or a sable/synthetic mix. Use a synthetic brush for transferring ink or paint to your dip pen.

13 Gouache: Gouache is basically the same as watercolor but has an additive to render it opaque. This allows for a denser, flat cover. Gouache is ideal for use with a dip pen and for calligraphic work.

CHOOSING PAPER

There is a vast range of suitable papers, so take time to explore, then experiment with what is available to you.

14. Vellum and parchment: These are prepared from animal skins and are the finest materials for the scribe. Use them for manuscripts and rolls of honor.

15. Pastel paper: This is an acid-free paper, with high rag content, made for use with chalk pastels. It comes in both bright and subtle colors and has a textured or smooth reverse, which is ideal for calligraphic writing.

16. Layout paper: This is the most economical practice paper. It is thin, smooth, slightly transparent paper, often used as overlay and cut-and-paste paper by designers.

17. Cartridge paper: This is inexpensive, smooth paper, which is good for

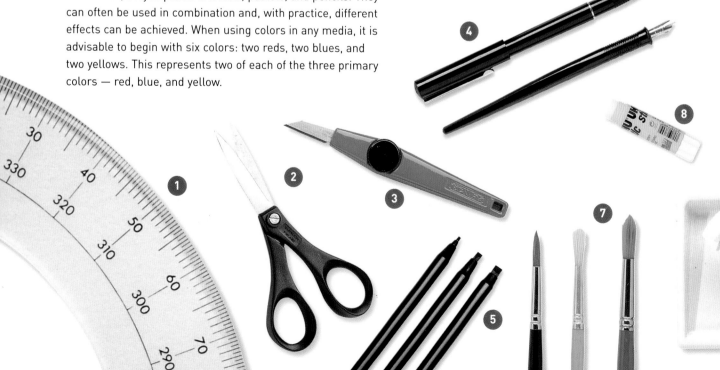

your first finished pieces of calligraphy. It can be bought in white and cream plus a whole range of bright colors.

18. Moldmade and handmade papers: These are the best for your finished work. Bought from specialist shops, handmade papers offer a huge range of qualities and textures that can really add to the finished effect.

PAPER INFORMATION

Paper is described using specific terms and measurements.

Paper thickness is measured by weight in pounds (lbs) or grams per square meter (gsm). The lower the number, the thinner or lighter the paper will be. The number relates to the weight of a ream (pack) of paper, which is 500 sheets. A paper weighing 90 lbs (190 gsm) will therefore be a thinner paper than one weighing 140 lbs (294 gsm).

Surface textures on high quality watercolor paper are described as hot-pressed, cold-pressed, or rough.

Hot-pressed (HP) paper has a smooth surface that is excellent for fine detail work such as botanical painting or fine calligraphy.

Cold-pressed (CP) paper has a slightly textured surface that is ideal for larger calligraphic work with illustration.

Rough paper has a highly textured surface and is used by experienced painters and designers where the rough texture can be used to enhance the work. An automatic or coit pen, or a reed can produce exciting effects.

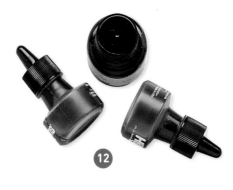

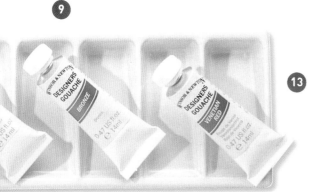

GETTING ORGANIZED

You are most likely to succeed with calligraphy if you can do it regularly. Keep all your equipment together and, if you can, keep a space on a table set up so that you can do a little practice whenever you have a few spare minutes.

Protect the table from ink spills, then prop up your drawing board either on the table, or on your lap, resting on the table edge (you will have to move the chair to do this).

Writing on a sloped board is better for your posture and also reduces the chance of blots from your pen. To avoid shadows cast on your writing, arrange for the light to come from your left if you are righthanded, and from the right if you are lefthanded.

When you are seated, position your ink and pens within easy reach, and secure the ink so that it will not spill.

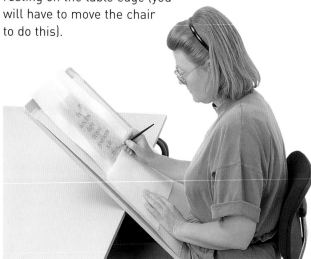

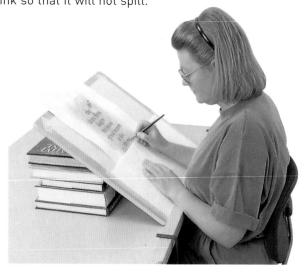

MONEY-SAVING TIPS

Remember that you do not need everything at once. It is better to start simply and focus on learning a basic alphabet until you can write it without constant reference to the exemplar.

For this, you will only need a pen, paper and ink. Your first few sheets are provided with this book.

● **Make your own** drawing board from wood. The wood need not be thick, but it must not bend. Wood panels from old kitchen cupboards are ideal. Alternatively, have a piece of plywood cut to size from a wood merchant, then sand the edges.

Pad the board with around six layers of newspaper. Iron the newspaper first to get rid of the center crease.

Add just one layer of white paper or blotting paper, and fix all the padding with masking tape. Do not wrap it around the edges because you need the edges clear in order to use a T square.

● **Dip pens** are less expensive than fountain pens. Prolong the life of your nibs by keeping them clean after use and storing them dry to prevent them from rusting.

● **A pad of layout** practice paper may appear costly but there are many more sheets in the pad than in a similarly-sized pad of cartridge paper. If you have a source of computer printout paper this may work, but test it first to make sure there is no ink bleed.

● **Avoid losing** ink through spills by cutting a hole in a sponge and wedging the ink bottle in the hole. This will stabilize the bottle and absorb any drips.

● **Make your own** disposable penrest using corrugated cardboard. This will stop pens from rolling off the table and getting damaged.

PADDING THE BOARD

Fix the paper down all around with masking tape. Do not go over the edge with the tape if you intend to use a T square. Leave the bottom open to slide your paper in.

PREPARING TO WRITE

Once you have all the equipment to hand, and your table is set up, you are ready to make some marks.

Follow the instructions below to learn how to hold and use the pen, ready for learning a script.

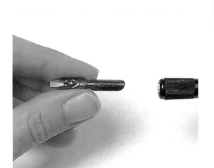

◆ 1 CHOOSING A NIB
Choose a wide nib and fit it into the holder securely. Keep pushing until the shank is fully inserted.

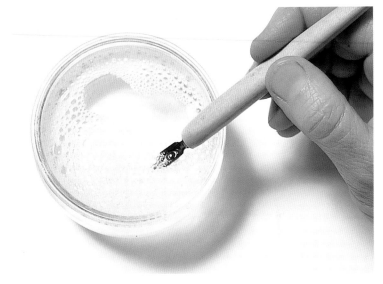

2 NEW NIBS
A new nib may be greasy or varnished, and may not accept ink properly, instead it will bubble off. If this happens, wipe the underside of the tip in a detergent solution, or use saliva and a tissue. Now the ink will spread easily along the nib.

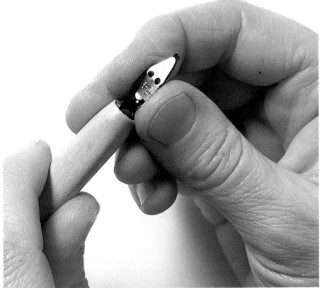

3 FITTING THE RESERVOIR
Slip on the reservoir. If it is too tight, squeeze the sides open slightly — it is made of brass, and will bend easily.

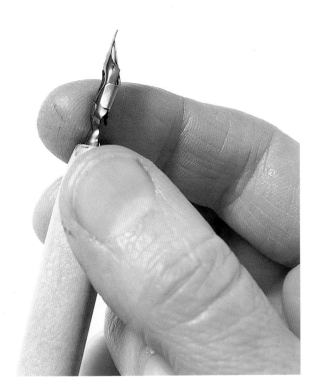

FITTING THE 4 ◆ RESERVOIR & NIB
Verify that the pointed part of the reservoir is touching the underside of the nib at around ⅛ in (2mm) from the edge. If it is not, take the reservoir off and bend it.

◆5 LOAD THE INK

Dip the pen in the ink. Wipe the excess ink on the edge of the pot. Alternatively, feed the nib with a brush.

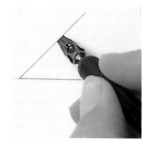

◆6 PEN ANGLE

If you are right-handed, hold the pen as shown. All scripts have a particular angle at which to hold the nib relative to the writing line. Try holding it at 45° to the horizontal.

◆7 DRAWING LINES

With the pen still at 45°, make vertical and horizontal lines. All the lines should turn out the same thickness.

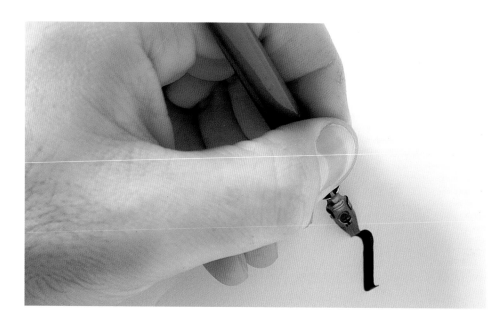

MAKE 8◆ SOME ZIGZAGS

The pen angle is the angle of the nib relative to the horizontal writing line. Start with a 45° slant and make some zigzags. The zigzags should be alternately thick and thin. Rule a line to help you to go straight.

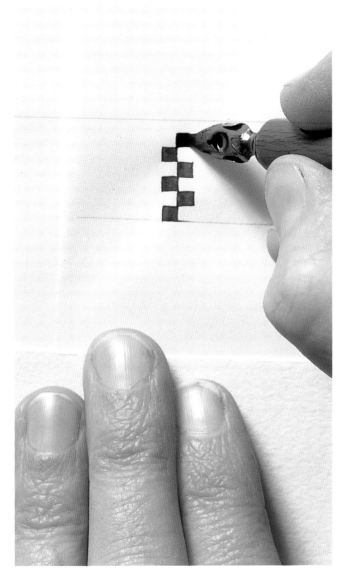

◆● 9 LETTER HEIGHT

The width of the nib governs the height of a letter. Foundational script is four nib-widths high and Italic script is five nib-widths high. You can figure this out by making a nib-width ladder. Hold the pen at an unnaturally vertical angle to the writing line, then go upward from the line and mark squares that just touch, in staircase fashion.

⚷ 10 PEN PATTERNS

Now make these patterns with a pen angle parallel to the horizontal writing line (a 0° angle).

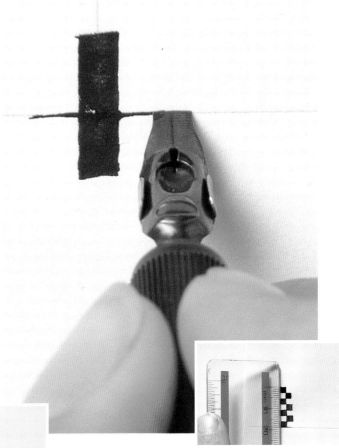

◆● 11 SPACING YOUR LINES

When you have drawn the required number of nib-widths for the particular script you are writing, use a ruler or a pair of dividers to measure the distance from the line to the top of the top square. Mark that measurement repeatedly down both sides of the page, then draw lines across the page, joining the marks. Alternatively, you can fix the paper to the drawing board and use the T square to make parallel lines from your marks.

FOUNDATIONAL HAND

STAGE 1: Getting started

The Foundational hand is a classic, rounded, upright style, familiar in many typefaces. Also known as Round hand, it actually originated in the tenth century and is sometimes also referred to as Roman, because it uses Roman capital letters. The best way to start Foundational is to familiarize yourself with the correct pen angle and size and shape of the letters.

PEN ANGLES

Consistent pen angle is important because it keeps the thick and thin parts of the pen in the right places. Hold the pen nib constantly at 30° (two o'clock on a clock face) for all letters except diagonals, where the first stroke is made at 45°.

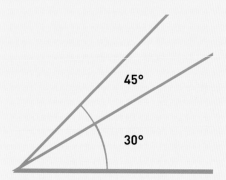

LETTER HEIGHT

The height of Foundational letters is four times the width of the nib. Turn the pen sideways to make squares with the nib, as shown, then rule lines that far apart.

LETTER SHAPE

Foundational is a very rounded alphabet, governed by the shape of the **o**.

LETTER SLOPE

Foundational letters are upright and should not lean.

PEN PATTERNS

Pen patterns help you to maintain the correct pen angle and to understand the basic form of the letters. The component strokes of the Foundational hand are curves and straight lines, from top to bottom or left to right. Constant repetition of these strokes will alert you to the structure of the letters, give you confidence, and help you to develop a rhythm that will improve your writing. Some of these patterns can be used alone as border decorations.

Practice these strokes before you make the letter. Make sure you keep the pen at a 30° angle.

Now try turning the strokes into these related letters.

Keep these upright and start with the serif (the little lip).

Round the top, like part of an **o**.

Put them together to make these letters.

Half-moon shapes must start and end on a thin point. Do this by keeping a constant 30° pen angle.

This taller stroke requires practice to eliminate wobble.

Join the strokes to make these letters.

Do this diagonal stroke at 45°, so that it does not come out too thick.

Go back to a 30° pen angle for the right to left stroke.

Try it again.

Now make **v**, **w** and **x**.

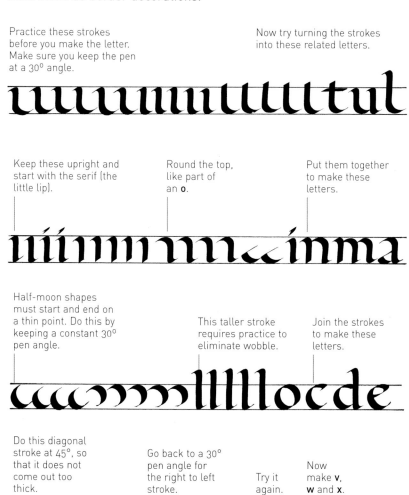

STAGE 2: The Alphabet

LOWER CASE LETTER STRUCTURES

Most letters share a stroke formation with other letters. Below are the underlying structures of key letters, with those formed in a similar way listed on the right. As the Foundational script is based upon the round **o**, even **t** and **l** echo its circular shape. The diagonal letters are related by width. Exceptions are listed at the end.

THE STRUCTURE	THE STROKES			THE GROUP

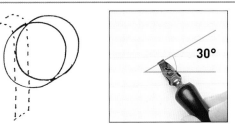

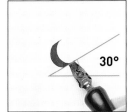 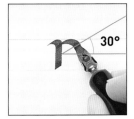 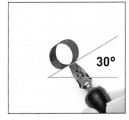

Note where the thin parts are. The left and right edges of the pen make circles.

Start just below the top line and move to the left to start the half-moon shape.

Make a semicircular sweep, ending with an upward, thin point that anticipates the circle.

From the top, make the other half of the semicircle, blending the thin points together.

cep dbq

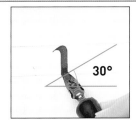 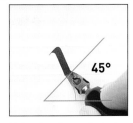 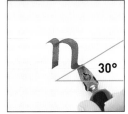

The arch joins the stem high, beginning with the pen in the stem.

Start with a strong, curved serif, not a tiny hook. Make a vertical stem.

Put the pen into the stem where the curved serif ends. Make a very wide curve to match the **o**.

Continue the stroke parallel to the stem, ending with a smaller curved serif.

mr hai

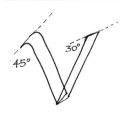

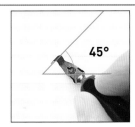 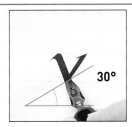

Make the first stroke steeper at 45° to avoid it being too thick. Revert to 30° for the second stroke.

Hold the pen at the steeper angle and make a small, curved serif.

Make the diagonal stroke without any curve.

Revert to 30°, make a small, hooked serif and pull down to the base.

wxy kz

The bottom curve describes part of the **o**, as in **u** and **l**, and is not an upward flick.

Start just above the top line and go straight until two-thirds of the way down.

Make a sweeping curve that mimics the bottom half-moon of the **o**. End on a thin point.

Make the crossbar sit under the top line and protrude to nearly the width of the curve.

uls fjg

THE ALHABET: LOWER CASE LETTERS

Foundational letters, at four nib-widths high, are sturdy, rounded, upright letters. Any ascenders (upward extensions) or descenders (downward extensions) should protrude no farther than three-quarters of the body height. You will soon find that you can judge this by eye. Remember that all letters are related in some way to the round **o**. Be careful to maintain the pen angle.

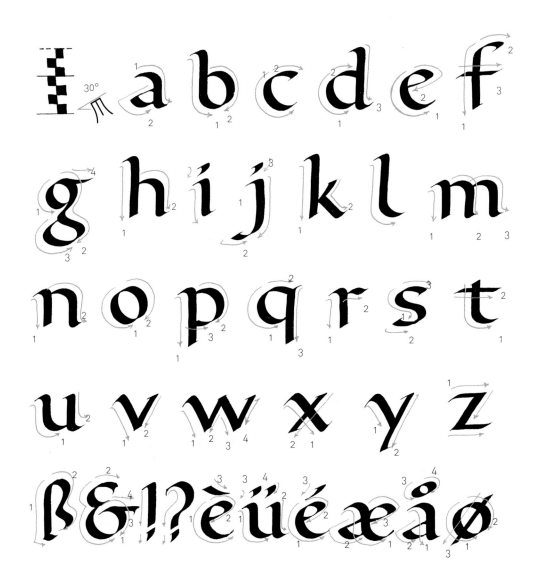

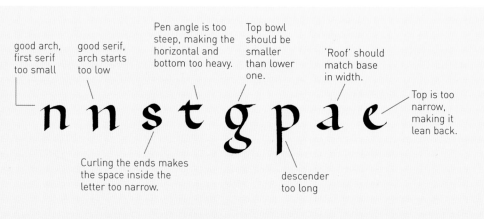

COMMON MISTAKES

A common mistake made with the Foundational is allowing letters to lose their affinity to the round **o**. Other mistakes include altering everything because of a bad pen angle (**t**), weak arches, caused by joining too low (**n**), and wrong proportions (**g** and **p**).

good arch, first serif too small

good serif, arch starts too low

Pen angle is too steep, making the horizontal and bottom too heavy.

Top bowl should be smaller than lower one.

'Roof' should match base in width.

Top is too narrow, making it lean back.

Curling the ends makes the space inside the letter too narrow.

descender too long

PRACTICING FORMS AND SPACING

Once you are familiar with the alphabet, it is time to tackle words. Careful spacing is essential if you are to achieve an even density of text. Spacing has to be done visually, because of the awkward shapes inherent in some letter combinations, such as **e** followed by **a** or **s**. Straight-sided letters next to each other need extra space.

LETTER SPACING

Good letter spacing
The letters **e** and **s** are tucked close together to combine their inherent spaces. For balance, two adjacent curves (**o**, **d**) are given a slightly smaller space than two straight lines (**d**, **u**).

est modus

Letters like **e** and **s** have their own space, so can be tucked close together.

Aim for even white space between and within all letters.

Poor letter spacing
The first word is more generously spaced than the second, giving prominence to the spaces between letters in the first, but to the inside spaces of letters in the second.

est modus

slightly too far apart

too far apart

These spaces should be wider.

Good letter spacing
The letter **r** always requires the following letter to be tucked under or close to it, to avoid a big blank. The space between two straight sides (**i**, **n**) matches their internal widths.

in rebus

Vertical strokes are the same distance apart.

Tuck **e** under **r** to even out spacing.

Poor letter spacing
The first word is too closely spaced and the second starts wide and is then squashed. Turn the page upside down to see this uneven spacing more clearly.

in rebus

too close

too close

WORD SPACING

The interlinear space (space between lines) should be twice the writing height. Keep spaces between words minimal.

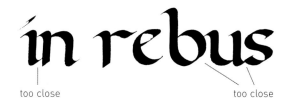

Aequam memento rebu

in arduis; servare mente

CAPITAL LETTER STRUCTURES

First developed by the Romans more than a thousand years ago, Foundational, or Roman, capital letters fall into four width groups, as shown below. All are related to the square, or a circle within the square. Many letters are three-quarter width or half width, five letters fit the circle, one fits the square (**M**), and one bursts slightly beyond it (**W**).

THE STRUCTURE	THE STROKES			THE GROUP

Imagine a square, and fit this group into approximately three-quarters of it.

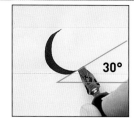 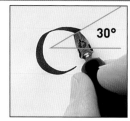 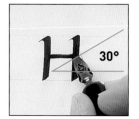

NTAV UXYZ

Make a small, curved serif then pull downward in a perfectly vertical stroke.

Make a second, identical vertical stroke to establish the width.

Link the two verticals at a central point, beginning and ending inside the stems.

These circular letters use most of the **O** shape and are therefore wider than you might think.

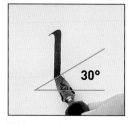 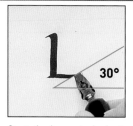 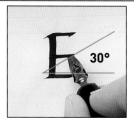

OD QC

Make a semicircular stroke as if starting an **O**. Both ends should be pointed.

Make a flattened top curve, with a tiny hook serif.

Make a central horizontal stroke, then downward to blend with the curve.

The letters in this group are only half as wide as they are high. The first serif gives corner strength.

FPBK LRSJ

With a small, curved serif, make the stem.

Start the base stroke just to the left of the stem.

Start the other horizontal strokes inside the stem, not next to it. Finish with a tiny hook serif.

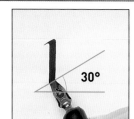

M fills the square, slightly bursting out at the foot, but be careful not to overemphasize this.

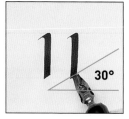 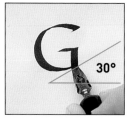 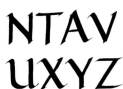

W

Slim down this first stroke by making your pen angle steeper.

Make a wide **V**, starting inside the top of the first stroke.

Start inside the top corner and make a straight, slightly outward downstroke.

THE ALHABET: CAPITAL LETTERS

Keep the capital letters upright and rounded, with a 30° pen angle. Test that the horizontals in **T** and **H**, for example, are thinner than the verticals. These capital letters are often made seven, eight or nine nib-widths high when used without the lower case.

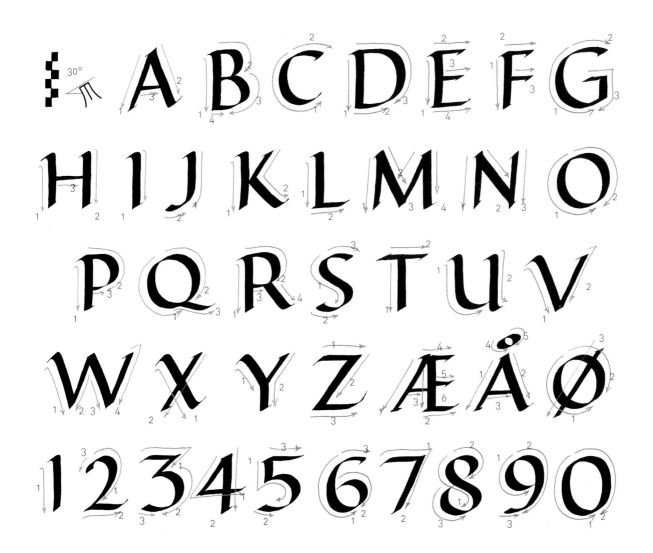

COMMON MISTAKES

The easiest place to go wrong with Foundational capital letters is with width (**D, E, M**) and pen angle (**E**), resulting in an unbalanced thickness in letters. Overlapped corner joints (**K, R**) can cause dense areas, and sometimes subtlety is lost (**N, S**).

Too narrow; this should be three-quarters the width of **O**.

All three strokes are the same thickness. Make the pen angle steeper to make uprights thinner.

Overlapped joint makes thick waists.

The two outside strokes are sticking out too far. Make them more upright.

Too wide; this is a half width letter.

Curves are too tight, making a narrow, heavy letter.

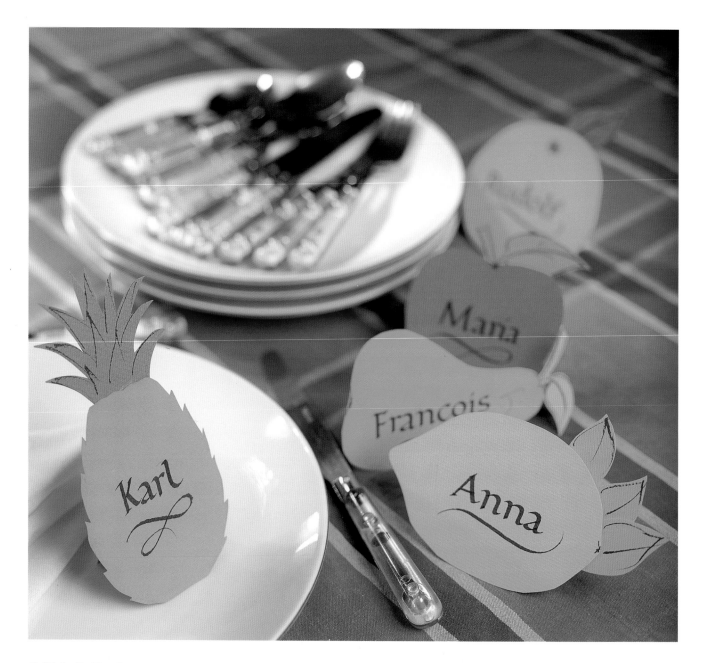

STAGE 3: Project

PLACE LABELS

Making place labels for an informal dinner party is an attractive first calligraphic project. The calligraphy itself is straightforward, using just a first name on each card embellished with a simple underline. When you have gained some experience, try writing with smaller pens so that full names can be used. Choose brightly colored paper and have some fun with the details: in this example, where the labels are cut into the shape of fruits, you can add to the effect by pasting on paper leaves, stalks, and other features. For more serious occasions, such as committee meetings, cut plain rectangular cards and have your fun by writing in color or by decorating the edges with some of the pen patterns learned earlier.

YOU WILL NEED

Practice paper

Pencil

Ruler

Dip pen and ink

Brightly colored paper

Thin cardboard

Scissors

Glue

◆●1 WRITING TRIALS

Rule lines at four times the width of your nib and write out the names, both for letter practice and to see how long each name is.

◆●2 DRAW AND CUT

Draw some fruit shapes. You can take your designs from real fruit, or trace and enlarge them from magazine pictures. Cut out the designs with scissors.

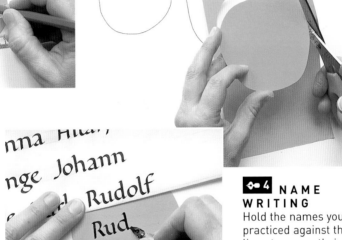

♦3 WRITING PREPARATION

Rule lines on the fruit shapes ready for writing. Use a sharp pencil for fine lines but press lightly so that the lines can be erased later.

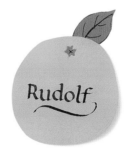

◆●4 NAME WRITING

Hold the names you have practiced against the lines to gauge their lengths. Mark lightly where each name should start, then write it out.

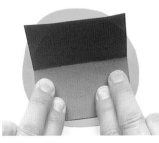

♦5 MAKING A STAND

Cut a piece of cardboard, fold it, and glue it to the back of the fruit shape to make a stand.

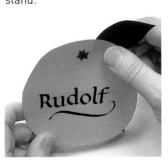

◆●6 FINISHING TOUCHES

For extra realism, cut out leaf shapes or other details in suitable colors and paste them onto your place labels.

UNCIAL HAND

STAGE 1: Getting started

The Uncial hand is a capital, or majuscule, hand, probably evolved from North African scripts and in use in Europe as a book script from the fourth to the eighth century. The version shown here is a modern form, written with a comfortable pen angle. It is a very round letter form, well-spaced along the line, with any ascenders and descenders minimal in height. It is written with a very rhythmical movement and looks better in longer lines of text.

PEN ANGLES
It is important to keep the pen's nib at 25° all the time you are writing. This is how the shapes of the thick and thin strokes are made. If you change the angles, the shapes will alter. The diagonal letters **v**, **w**, **x**, **y** can have a slightly steeper angle on the first stroke.

25°

LETTER HEIGHT
Uncial is written at 4 times the width of your nib for the height of the letter. Measure the height by making nib width squares as shown, then rule the tramlines that far apart.

LETTER SLOPE
Write Uncial letters upright.

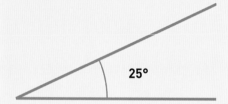

LETTER WIDTH
The letter **o** is an extended circle. All the round letters in the alphabet relate to an extended **o** shape.

PEN PATTERNS
Uncial letter stems are short and the letters themselves are sturdy. All round letters are based on an extended circle which, when placed together, creates space along the line, giving a laterally stretched appearance to the letter forms. The diagonal letters are the width of **o**.

Practice these patterns to ensure you are keeping the correct 25° angle on your nib.

Try some of the straight letters with these shapes.

Try to keep these shapes as round as you can.

This shows the two pen strokes which make round letters.

Try some round shapes.

These patterns go from left to right.

Writing from right to left makes these strokes difficult.

These are the diagonal letters that you can write.

Now the patterns become more complicated.

Still maintain the 25° angle on the nib.

These small patterns are the shapes of **s**.

Now try these letters.

STAGE 2: The Alphabet

CAPITAL LETTER STRUCTURES

The beginnings of the lower case letters can be seen in the Uncial capital script. The letters **D**, **H**, **K** and **L** have ascenders that are higher than the capital height, and **F**, **G**, **P**, **R** and **Y** fall slightly below the base line. Ascenders and descenders should extend between one and two nib widths. All curved structures in the Uncial hand relate to the extended **O** shape. Serifs are small and restrained.

THE STRUCTURE	THE STROKES			THE GROUP

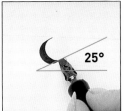 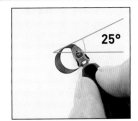 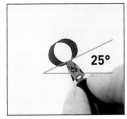

The letter **O** is wider than a circle and the top strokes of **C**, **G**, **Q** and **S** are flattened.

With the pen at 25°, pull down toward the base line in a well-rounded curve.

Overlap fractionally at the top to join smoothly.

Pull down to the base line in a smooth, round curve, overlapping at the bottom carefully.

cedg pqs

 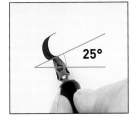 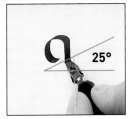 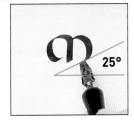 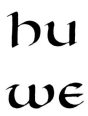

The **M** is almost two **O** shapes wide with the second stroke springing from the central stem.

Make the same smooth curve as for **O**, although not as long.

Overlap carefully at the top, form a short curve, then pull straight down to the base line.

Make another arch based on the **O**. Both arches should balance internally in area and shape.

hu we

 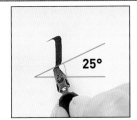 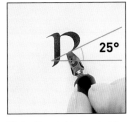 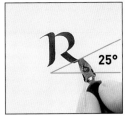

The bowl of **R** is an extended **O** with a short tail.

Hold the pen at 25°, make a serif, then pull vertically down to fractionally below the base line.

Make the right-hand side of an extended **O**, ending below halfway. Do not meet the vertical.

Finish the letter with a short, diagonal tail.

BFIJ LT

 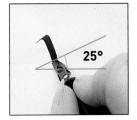 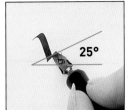 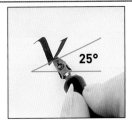

A wide letter at the top, **V** commands the same area as **O**.

With a pen angle slightly steeper than 25°, make a serif and pull the pen diagonally to the right.

At the bottom, push the pen up very slightly to the right to create a point.

Flatten the pen angle, make a small serif, then pull the pen down to overlap the base stroke.

wxa yznk

THE ALHABET: CAPITAL LETTERS

Early forms of the Uncial hand were uncomplicated to write. This modern example, based on the Stonyhurst Gospel, a late seventh-century English manuscript, has a fairly consistent pen angle and round, well-spaced letter forms. Note the small ascenders and descenders, which represent the beginnings of our lower case letters.

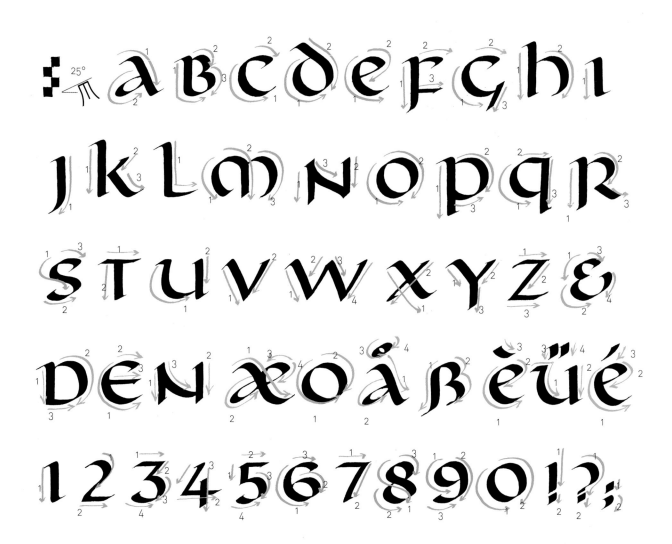

COMMON MISTAKES

Most mistakes occur with letters that are not wide enough or that are placed too close together, making them look cramped. Remember that all the letters are based on an extended **O**, giving them a very round, almost stretched look when placed along the line. Be careful to extend ascenders and descenders only slightly beyond the **X** height, or main body of lettering.

Ascender of **d** should be farther left to give better shape.

joint too low

Do not slope shoulder.

joint too thin

Do not curve this stroke, keep straight.

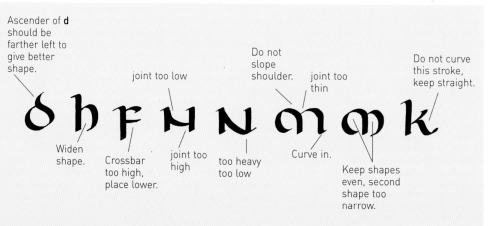

Widen shape.

Crossbar too high, place lower.

joint too high

too heavy too low

Curve in.

Keep shapes even, second shape too narrow.

PRACTICING FORMS AND SPACING

Look at the whole alphabet to see how wide all the letters are. Round shapes are based on the extended circle and diagonal letters occupy the same area. All arches are related to the round arches of **O**. Ascenders and descenders extend only fractionally above and below the lines. Do not dot **I** or **J** because Uncials are all capital letters.

LETTER SPACING

Good letter spacing
Spaces inside and between the letters must balance visually. There should be a slightly larger space between words, the maximum being the width of **N** or **O**. This will create a regular pattern along the line.

Poor letter spacing
Letters placed too close together make words look cramped. The writing looks uneven and spoils the lateral movement in the text.

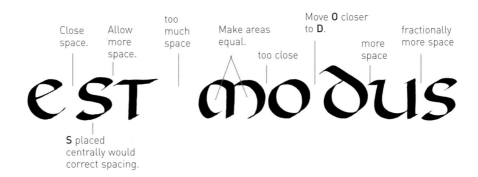

Close space. Allow more space. too much space. Make areas equal. too close. Move **O** closer to **D**. more space. fractionally more space

S placed centrally would correct spacing.

Good letter spacing
The inside space of the letter is generous. Balancing the space between the letters makes for easier reading.

Poor letter spacing
I and **N** are too close and **REB** is too spacious in comparison. This has the effect of breaking the uniformity and rhythm of the writing.

Allow more space. Allow **O** shape for space between words. Close space fractionally. too close, looks heavy. extra space

Shorten tail to move **E** nearer.

WORD SPACING
The Uncial hand comprises wide, robust shapes and therefore benefits from being written in long lines of text, creating a stretched band appearance. The ideal interlinear space is one and a half times the **X** height of six nib-widths. However, if the lines are short, more interlinear space is required to separate the bands of writing and improve legibility.

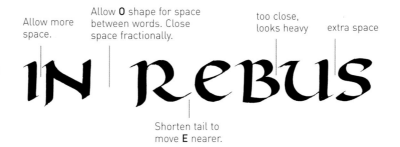

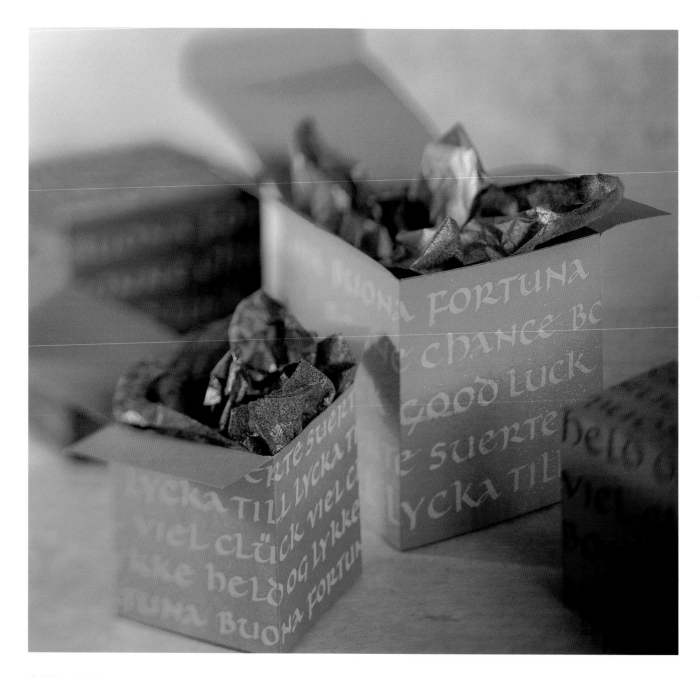

STAGE 3: Project

MAKING BOXES

Handmade boxes holding small gifts are a pleasure to make and to receive. Uncial script lends itself well to this form of project—the round, even letters form an attractive pattern in their own right, over and above the sentiments they convey. Before you begin, it is important to decide on your greeting, and on the type of packaging that will best suit the gift inside—bright and breezy, or subdued and subtle. Thick card will make your boxes stronger but will be more difficult to cut. To make your box bigger or smaller, simply increase or decrease the measurements of the template provided equally.

YOU WILL NEED

- Pencil
- Metal-edged ruler
- Eraser
- T square
- Craft knife
- Scissors
- Paint palette
- Dip pen and square-edge nibs (sizes 2½ and 3½)
- Layout paper
- Designers' gouache
- Pastel paper (76 lbs / 160gsm) or thin cardboard
- Repositional glue
- PVA or craft glue
- Bone folder
- Ribbon

el glück
ix buona fortuna bonne chance
ierte bonne chance suerte

uerte bonne chance···
hance lycka till viel glück
na held og lykka lykke

1 WRITING TRIALS

Experiment with different pen sizes, letter weights and variations. Make a note of which pen sizes you use.

CUT 2 AND PASTE

Write your chosen text onto layout paper. Consider carefully the letter forms, and the word and letter spacing. Cut your best lines into strips and stick them onto a clean sheet of paper

3 COLOR TRIALS

Experiment with colored gouache to find the most appropriate color for the box. In this case, warm, bright colors best suit the greeting, with complementary colors giving extra impact.

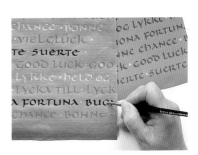

4 PAPER TRIALS

Try different papers, such as brown parcel wrapping paper, with colored and gold gouache.

5 PAPER PREPARATION

Using the template measurements supplied, rule the box shape onto your chosen paper or thin cardboard. In this case, the paper will be thick enough to make a sturdy box when folded. Rule your writing lines carefully.

LETTER **6** FORMATION

Write across the template in Uncial script. Ensure that your letter forms are good and that your spacing is correct. You can make and write on several boxes from one sheet of cardboard or paper.

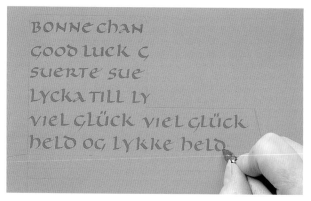

7 SCORE AND CUT

When the writing is completed, score the fold marks with a bone folder or similar blunt implement. Cut out the box shape carefully with a craft knife.

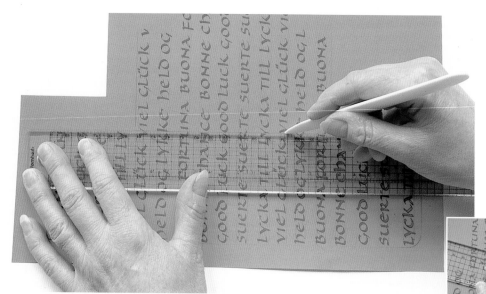

8 TIDY AND TRIM

Carefully erase all ruled guidelines. Trim the corners as indicated on the template.

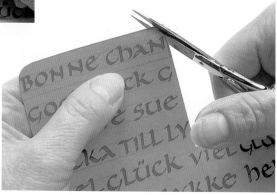

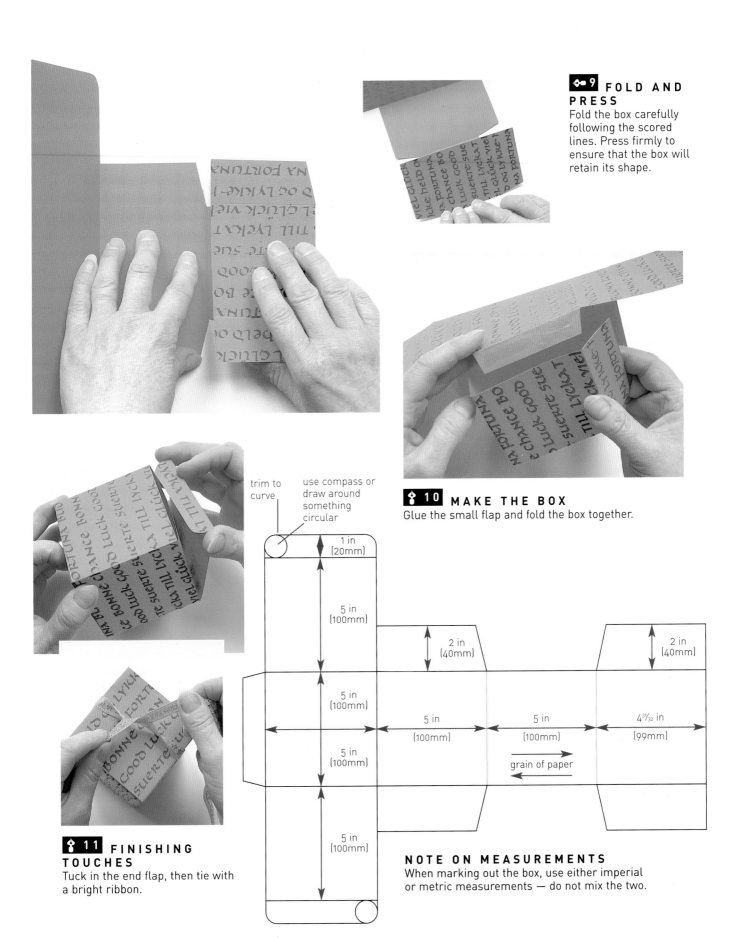

9 FOLD AND PRESS

Fold the box carefully following the scored lines. Press firmly to ensure that the box will retain its shape.

10 MAKE THE BOX

Glue the small flap and fold the box together.

trim to curve

use compass or draw around something circular

1 in (20mm)

5 in (100mm)

2 in (40mm)

2 in (40mm)

5 in (100mm)

5 in (100mm)

5 in (100mm)

5 in (100mm)

5 in (100mm)

4³¹⁄₃₂ in (99mm)

grain of paper

11 FINISHING TOUCHES

Tuck in the end flap, then tie with a bright ribbon.

NOTE ON MEASUREMENTS

When marking out the box, use either imperial or metric measurements — do not mix the two.

CAROLINGIAN HAND

STAGE 1: Getting started

Unlike many alphabets that simply evolved, the Carolingian hand was consciously designed in the ninth century as a readable and elegant style. It is a very rounded, slightly sloped hand, written with a fairly flat pen angle. The ascenders and descenders are tall compared to the shallow main body of the letters. Watch for the upstrokes and overstrokes which give the letters rhythm.

PEN ANGLE
This alphabet needs a shallow pen angle, about 25° or 30°. Be careful not to twist the pen to a different angle when you make the curved strokes, as this will make the lines thick in the wrong places.

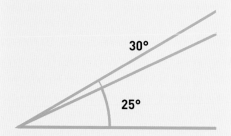

LETTER HEIGHT
The main body of the letters is written at only three times the width of the nib. Hold the pen sideways and make squares with the nib, then rule tramlines. Leave a big space between sets of tramlines.

LETTER SLOPE
Carolingian letters slope about 5° from the vertical.

LETTER WIDTH
Most letters are slightly wider than their height and relate to the **o** in terms of width and arches.

PEN PATTERNS
Follow these patterns to develop an understanding of the basic building blocks of the Carolingian alphabet. Repeat the patterns until they are consistent, then use the shapes to make the letters shown. The upstrokes, overstrokes and rounded strokes are important characteristics.

Start with a sideways movement for the serif, then pull straight down.

This is an 'up-and-over' movement, and will need much practice.

Put the strokes together to make these round, arched letters.

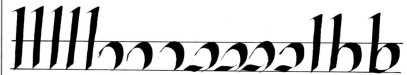

As above, but longer; this needs a steady hand.

more practice in up-and-over arches

When combined, these patterns make **h** and **b**.

Make sure you keep to 25° to make these half-moons.

Begin and end with thin points, keeping them rounded.

Hide the joints and keep the letters wide.

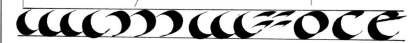

This pattern needs a steeper pen angle of about 35°.

Right to left strokes; do not make them too thin.

These patterns make all of these letters.

STAGE 2: The Alphabet

LOWER CASE LETTER STRUCTURES

Look carefully at the diagrams to see how wide and rounded Carolingian letters are. They are shown here in four groups: wide **o** shapes, up-and-over strokes (**n** group), diagonals, and the remaining letters, which do not fit into any one group. Practice the principles of each letter before trying the others in the group.

THE STRUCTURE	THE STROKES			THE GROUP

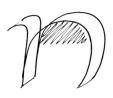

With circular letters, thin points show near the top and bottom. The letter **o** is wider than it is high.

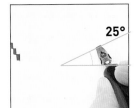

Position your pen just below the upper line, not on it, watching your pen angle.

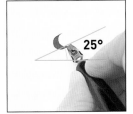

Make a wide semicircular sweep, stopping as the pen makes its thinnest point.

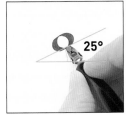

Make the other half of the semicircular sweep, being careful to blend both joints at the thinnest points.

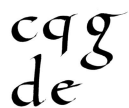

cq g de

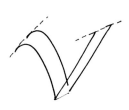

The branching stems in this group make smooth arches inside the up-and-over strokes.

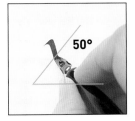

Make a small, curved serif then pull downward to the base line.

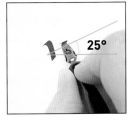

From the base line, lift the pen in a smooth arc, emerging from the stem near the top.

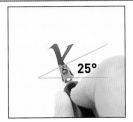

Continue the stroke downward, slightly straighter. A serif here is optional.

mpr bh ı

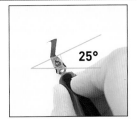

The first stroke of diagonal letters is made with a steeper pen angle to avoid it being too thick.

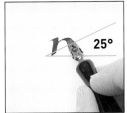

Hold the pen at twice the usual angle – 50° – and pull the pen diagonally, with a slight curve.

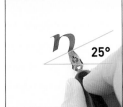

Return to the 25° angle, judge the letter width by eye and start with a hook serif.

Make a right to left diagonal stroke, looking ahead to finish inside the previous stroke.

wxy akz

Note how **s** fits the **o** shape, with an almost horizontal middle stroke and flattened ends.

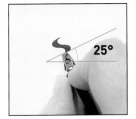

Make a small semicircle, then a near horizontal, and finish with another semicircle.

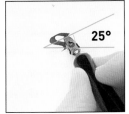

Join at the thin point and pull to the right, ending with a tiny hooked serif.

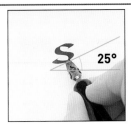

Start with the tiny serif, and pull to the right, blending thin points.

tuj fl

THE ALHABET: LOWER CASE LETTERS

The letters in this alphabet have an obvious family resemblance in the smooth, rounded, wide shapes, tall ascenders and gentle forward slope. Even the diagonal letters conform to this pattern, through width and sloping axis. The ascenders stretch four nib-widths above the tramlines, with the descenders stretching a similar distance below.

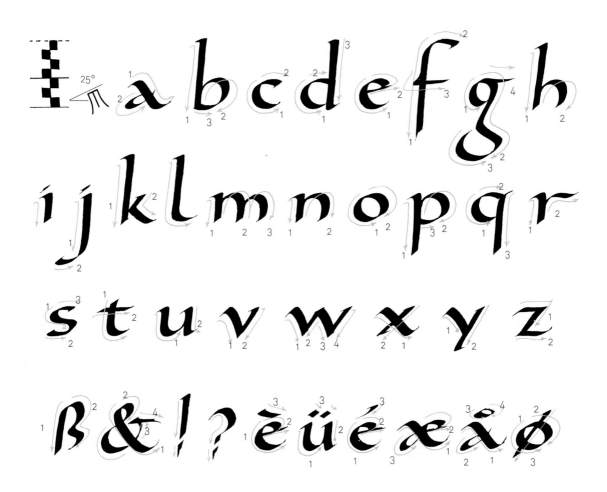

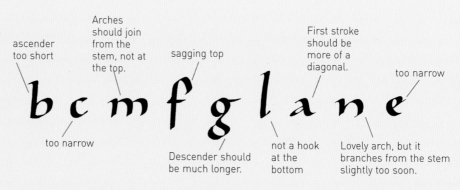

COMMON MISTAKES

Carolingian can look like a poor Italic or Foundational hand if the arches, widths, nib-widths or ascender heights are wrong.

ascender too short

Arches should join from the stem, not at the top.

sagging top

First stroke should be more of a diagonal.

too narrow

too narrow

Descender should be much longer.

not a hook at the bottom

Lovely arch, but it branches from the stem slightly too soon.

PRACTICING FORMS AND SPACING

Combining letters into words requires attention to how well they fit together. For example, the **r** in this alphabet is fairly long, leaving a big space underneath, which can spoil the even rhythm. A very wide, rounded alphabet like this needs careful handling in order to mesh the awkward letters together.

LETTER SPACING

Good letter spacing
Where **s** follows **e**, their internal spaces are adjacent so the letters need to be put close together. The widest space is between two uprights such as **d** and **u**.

e next to s means two spaces together: do not allow any more space.

Even spacing of verticals is important.

est modus

Poor letter spacing
The space between **e** and **s** is too wide and the second word is too tightly packed.

too close

Two verticals close together are very noticeable in these wide letters.

est modus

too much space

Good letter spacing
The problem of **r** leaving a big space is solved by not allowing the **r** to be too long and by tucking the next letter underneath.

in rebus

Put s fairly close to the u because it has its own integral space.

Tuck e under r to maintain even spacing.

Poor letter spacing
This line is evenly, but too generously spaced. A page of widely spaced text is hard to read.

slightly too wide

too wide

in rebus

slightly too far apart

e has its own space, so put the next letter closer.

WORD SPACING

Keep a minimal space between words of about the width of a lower case **o**. By contrast, the space between lines of text needs to be generous to allow room for the long ascenders and descenders.

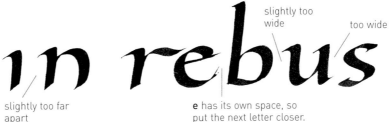

Aequam memento rebus

Keep spaces between words minimal.

Interlinear space must be three or more times the body height of the writing.

servare mentem. Nil desp

CAPITAL LETTER STRUCTURES

Carolingian capital letters are very similar to Foundational, but are wider, with a slight slope. The four groups shown illustrate the wide letters related to **O**, those with a branching top join (**D**), the diagonals, and those which belong to none of these groups.

THE STRUCTURE	THE STROKES			THE GROUP

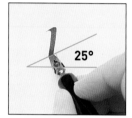 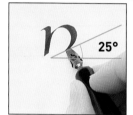 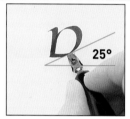

The letters in this group are wider than they are high.

Hold the pen just below the top line and move to the left to start a half-moon stroke.

Make a wide sweep ending on a thin point, anticipating the rest of the circle.

Joining at the thin point, make a second wide sweep and blend at the bottom.

C G Q

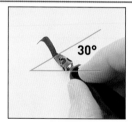 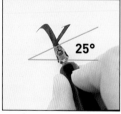 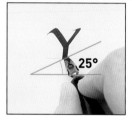

This set has a branching arch stroke which begins at the base of the stem. Note the wide arch.

Make a small, curved serif then pull down to the base line at a slight slope.

Pull upward in a smooth curve almost to the top, then continue around and down.

Join seamlessly by pulling from the stem to the thin point of the curve.

BRP FE

Left to right diagonal strokes need a steeper pen angle to avoid them becoming too thick.

Hold the pen at the steeper angle to make a slightly curved diagonal.

Revert to 25° to make a tiny hooked serif, then bring the diagonal down to join the other.

Make a downward stroke from the joining point to the base line, finishing with a small serif.

VWAX KMNZ

If the pen angle is correct, the horizontal stroke should be much thinner than the verticals.

Start with a small serif, pull downward at a slight slope and lift off sideways.

Establish the width by repeating this stroke, making the letter as wide as it is high.

Link the two verticals at a central point, beginning and ending inside the stems.

ILTJ US

 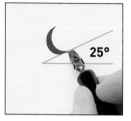 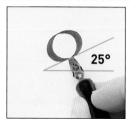 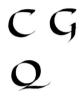

THE ALHABET: CAPITAL LETTERS

The upper case Carolingian alphabet continues the wide, sloping structures of its lower case. Make sure you maintain the shallow pen angle, as this will help you to keep the letters wide. The capital letters can be used either with the lower case or on their own. The numerals are small, wide, and sloping.

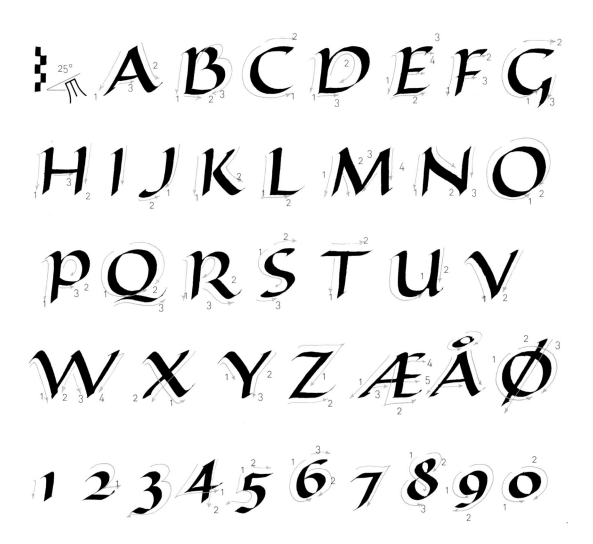

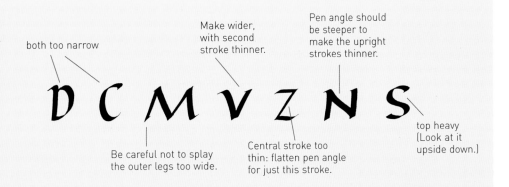

COMMON MISTAKES

Make sure you keep the letters wide (**D**, **C**) but not splayed (**M**). Watch your pen angle (**V**, **Z**, **N**), and avoid making letters top heavy (**S**).

both too narrow

Make wider, with second stroke thinner.

Pen angle should be steeper to make the upright strokes thinner.

Be careful not to splay the outer legs too wide.

Central stroke too thin: flatten pen angle for just this stroke.

top heavy (Look at it upside down.)

STAGE 3: Project

SCROLL

This impressive-looking presentation scroll would grace any formal occasion. Needless to say, it could have many fun uses as well! When you are working with this quantity of text, the cut-and-paste layout method helps you to experiment with varying line length and other page layout options for your design. When deciding on colors, choose papers and ribbon first, then mix the paint to match. Finishing touches are added using one of a number of attractive border designs. Remember that scrolls can be made portrait style, like a certificate, for variation. A cardboard tube covered in matching paper will protect your scroll and provide you with an attractive way of presenting it as a gift.

YOU WILL NEED

Practice paper
Ruler
Pencil
Dip pen
Gouache paints
Paintbrush
Paint palette
Water pot
Craft knife
Metal-edged ruler
Cutting mat or backing board
White and colored paper
Ribbon
Glue
Scissors
Ruling pen

◄■ 1 WRITING PREPARATION

Rule lines on practice paper to three nib-widths of your chosen pen. Write out the complete text, including any corrections.

♦ 2 CUT AND POSITION

Cut the text into strips and lay the strips out in various positions. Try a landscape (horizontal) version and a portrait (vertical) layout to explore the possibilities.

♦ 3 TRIAL PASTE

When you have decided on a design, paste the strips into position and make a note of the measurements.

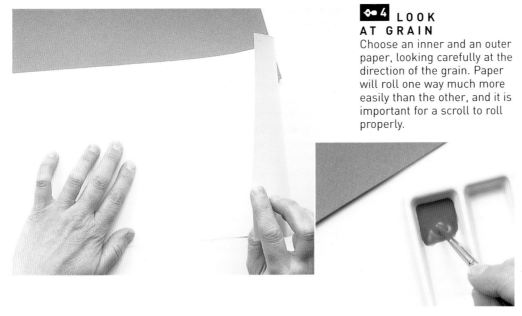

◄■ 4 LOOK AT GRAIN

Choose an inner and an outer paper, looking carefully at the direction of the grain. Paper will roll one way much more easily than the other, and it is important for a scroll to roll properly.

◄■ 5 MIX PAINT

Mix gouache paint to match the color of the backing paper. Dilute the paint with water with one brush-full at a time, until the paint has a creamy consistency.

Omne tulit punctum

⬥ 6 WRITING FOR REAL
Rule pencil lines on your white paper and write out the text in gouache, checking your paste-up frequently.

EXPERIMENTATION 7 ⬥
Try some pattern-making with the pen. Patterns can be complex or plain – diamond shapes and zigzags are effective and simple.

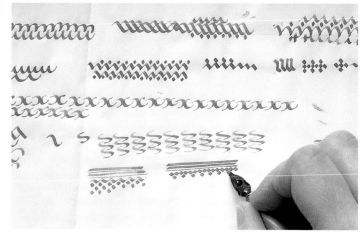

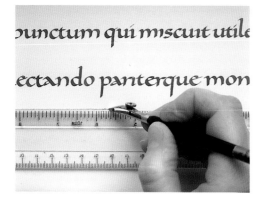

⬥ 8 RULING THE BORDER
Rule some fine lines in gold gouache for the border with a narrow nib or a ruling pen. Use the ruler, bevel side down, to prevent paint from running underneath.

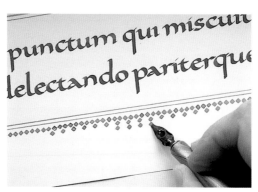

⬥ 9 FINISHING THE DESIGN
Complete the design with rows of diamonds made with the pen. The gold has a touch of blue in it, to bring out the blue of the outer paper.

⬥ 10 TIDY AND TRIM
When the paint is dry, erase the pencil lines and cut the paper to size, making the blue outer paper slightly larger.

◆ 11 FOLD TO ROLL
Fold over the end of the outer paper twice to catch in the white paper. The other end will remain free to allow for rolling.

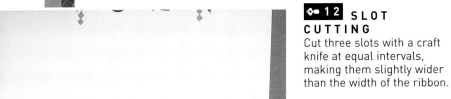

◆ 12 SLOT CUTTING
Cut three slots with a craft knife at equal intervals, making them slightly wider than the width of the ribbon.

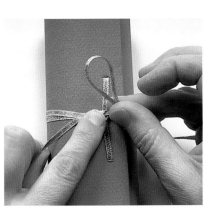

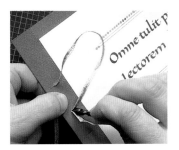

◆ 13 THREAD A RIBBON
Use a clean, wide nib to help you feed in the ribbon through the slots, finishing with both ends on the outside, so they will tie around the scroll.

◆ 14 FINISHING TOUCHES
If the inside looks too plain, make a ribbon bow and glue it in place over the ribbon joints. Roll the scroll and wrap the ribbon around to tie a bow.

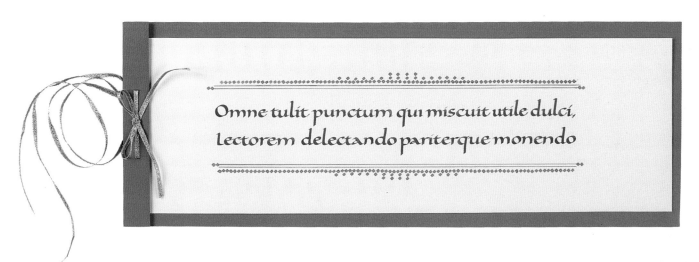

Omne tulit punctum qui miscuit utile dulci, lectorem delectando pariterque monendo

GOTHIC HAND

STAGE 1: Getting started

Gothic is almost geometric in its lower case letter formation. Many letters are made of identical strokes, with the white space inside the letter no wider than the black strokes. This creates a very dense 'picket fence' appearance in a line of text. It will feel strange at first to make the letters this narrow, with straight sides, no thin strokes, and hardly any curves.

PEN ANGLES
Hold the pen at a constant 40° for these angular Gothic letters. Any sharper will overemphasize the top and bottom diamond shapes instead of the upright strokes. Resist the tendency to shift the pen angle as you change direction on all the corners.

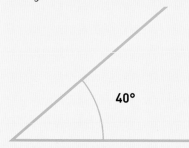

LETTER HEIGHT
Gothic script is usually written at five times the width of the nib, which includes the diamonds but not the ascenders or descenders. Measure this by making squares with the nib, as shown. Rule tramlines at this height before starting the pen patterns.

LETTER SLOPE
Gothic letters are rigidly upright and should not lean.

LETTER WIDTH
All these narrow letters are constructed with equal stripes of black and white.

PEN PATTERNS
As Gothic is very straight-sided with lots of parallel lines, it will be helpful for you to repeat the following patterns until you are making consistently identical strokes. The strokes are shown here in the most characteristic letter groups in the Gothic alphabet.

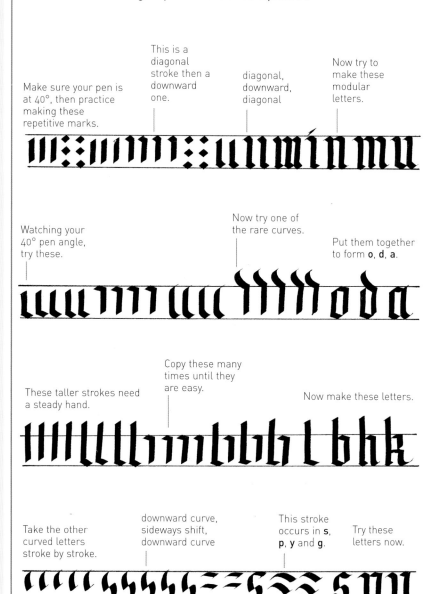

Make sure your pen is at 40°, then practice making these repetitive marks.

This is a diagonal stroke then a downward one.

diagonal, downward, diagonal

Now try to make these modular letters.

Watching your 40° pen angle, try these.

Now try one of the rare curves.

Put them together to form **o**, **d**, **a**.

These taller strokes need a steady hand.

Copy these many times until they are easy.

Now make these letters.

Take the other curved letters stroke by stroke.

downward curve, sideways shift, downward curve

This stroke occurs in **s**, **p**, **y** and **g**.

Try these letters now.

STAGE 2: The Alphabet

LOWER CASE LETTER STRUCTURES

The central characteristic of all these letters is the closely packed straight lines. Notice how narrow the letters are, with black strokes and white spaces of about equal width, and with very shallow ascenders and descenders. Look carefully at the way the component strokes are put together in the different groups.

THE STRUCTURE

THE STROKES

THE GROUP

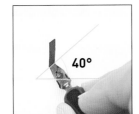

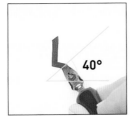

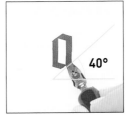

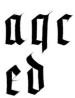

Verticals are close together. Top and bottom strokes are not quite parallel.

Start below the top line, watching your 40° pen angle, and stop before reaching the base line.

Continue the stroke diagonally to the base line.

From the top make a slightly flatter diagonal and continue down to meet the bottom corner.

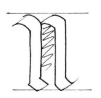

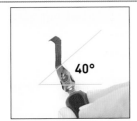

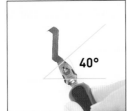

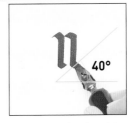

This letter consists of two almost identical shapes, touching at the top and open at base.

Start at the top line, make a serif like a diamond, then change direction.

Stop before the base line, change direction again and make the bottom diamond.

Without overlapping, join at the corner, make a diamond, a downstroke, then a diamond.

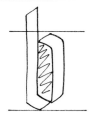

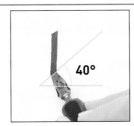

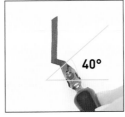

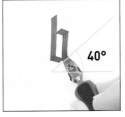

Ascenders are less than two nib-widths shallow for **b**, **h**, **l**, **k**, and **f**.

Start slightly above the top line and bring the stroke down, stopping at the base line.

Continue the stroke, but change direction to make the diamond.

Join without overlapping, then pull down to meet the bottom corner.

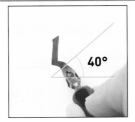

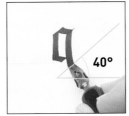

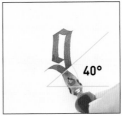

This group has curves. Keep the descender shallow and retain the narrow internal shape.

Start below the top line and change direction before reaching the base line to make a diamond.

Use slightly more jaunty strokes to join edge to edge, stopping a nib-width below the line.

Make a curved stroke left to right, joining edge to edge.

THE ALHABET: LOWER CASE LETTERS

This early hand is also known as Blackletter because of its dense appearance in a line of text. The letters shown below are more spread out to show the direction and order of the strokes. Keep the spaces inside the letters about the same width as the black strokes, and keep ascenders and descenders very shallow.

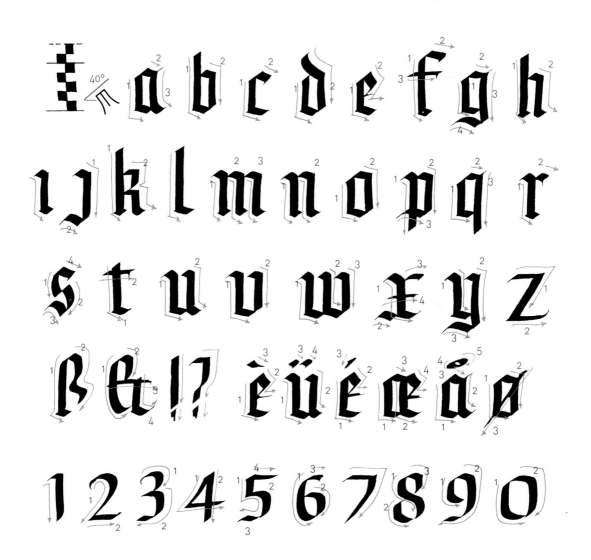

PRACTICING FORMS AND SPACING

The best test for an even Gothic hand, is to cover the top and bottom of a line of writing and see if there are any uneven spaces in the remaining central 'picket fence'. You should see even black and white stripes. Some open-sided letters, like **e** or **r**, have to be very closely followed by the next letter, to avoid a big white space within a word.

LETTER SPACING

Uprights are very evenly spaced.

Good letter spacing
The black and white stripes are even, and the space between the words is only a little wider.

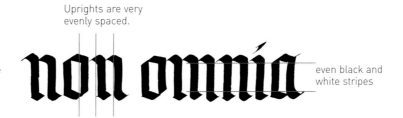

even black and white stripes

too close

too wide

Poor letter spacing
The spaces are uneven. All the letters are the correct width but some are too close to each other and others are too far apart.

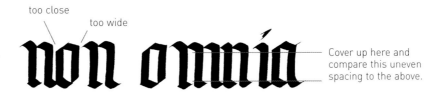

Cover up here and compare this uneven spacing to the above.

s can be difficult to space evenly, unless you see it as having the same verticals as the others.

Good letter spacing
The double **s** has been carefully handled to keep the rhythm of narrow strokes. Note how the adjacent open spaces between **e** and **s** have been fused.

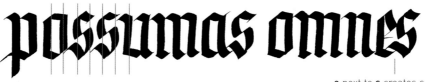

e next to **s** creates spaces that are best filled.

uneven spacing

Poor letter spacing
The adjacent **e** and **s** spaces combine to make a large blank area. Other letters are too close and the double **s** is too far apart.

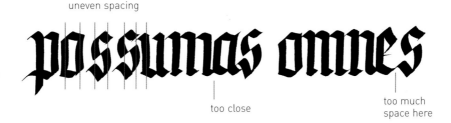

too close

too much space here

WORD SPACING
In a longer piece of text, the density of Gothic writing is very obvious. To maintain the dense texture, the space between words should be minimal and so too should the space between lines.

The interlinear space is usually one and a half times the height of the letters.

Keep the spaces between words fairly small, to retain the even texture of the writing.

Aequam memento rebus in ardu

Servare mentem·nil desperandu

CAPITAL LETTER STRUCTURES

Gothic capital letters are very decorative and, once you have grasped the common structural factors, are easier to make than they look. The letters are shown below in four groups, the last comprising letters that do not fit into any of the other three groups. The thin lines are made by turning the pen vertically to 90°.

THE STRUCTURE	THE STROKES			THE GROUP

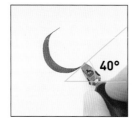

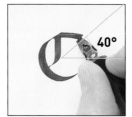

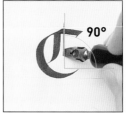

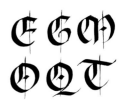

Both curve and top stroke join without overlapping. The only stroke to overlap is the decorative **J** shape.

Start below the top line, and make a gentle sweep ending in an upward hairline.

Make the **J** stroke and the top stroke overlap and touch the edge of the curve.

Turn the pen sideways to make the thin line.

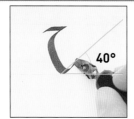

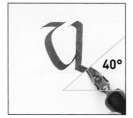

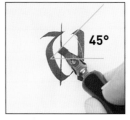

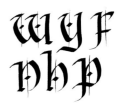

Note where the lines are thick and thin, and how the curved stroke joins the stem steeply.

Make a horizontal, then a steep curve, maintaining a 40° pen angle and sweeping upwards.

Make a diamond, then a downstroke, stopping before the base line, then another diamond.

Use the pen sideways for the optional thin line, then switch to 45° to make the optional diamond.

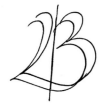

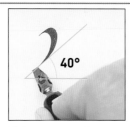

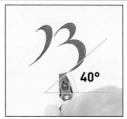

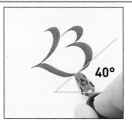

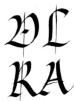

B starts with a vigorous curve. The top joint has the same branching motion as in the group above.

Make a curve ending above the base line in a point.

Make another curve to form a number three, ending in a point.

Sweep the last stroke across to meet the curves seamlessly.

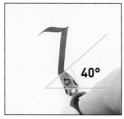

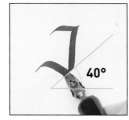

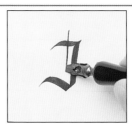

Note how the bottom curve joins the edge of the stem without overlapping.

Make a slightly wavy top stroke, then a straight downstroke.

Curve the bottom stroke to join edge to edge.

Turn the pen sideways to make the thin line.

THE ALHABET: CAPITAL LETTERS

In complete contrast to the lower case, Gothic capital letters are open and ornamental, designed to provide some relief from the rigidity of the main text. They are the least standardized of any alphabet and many variants exist. Do not write whole words in these capital letters as they will be very difficult to read.

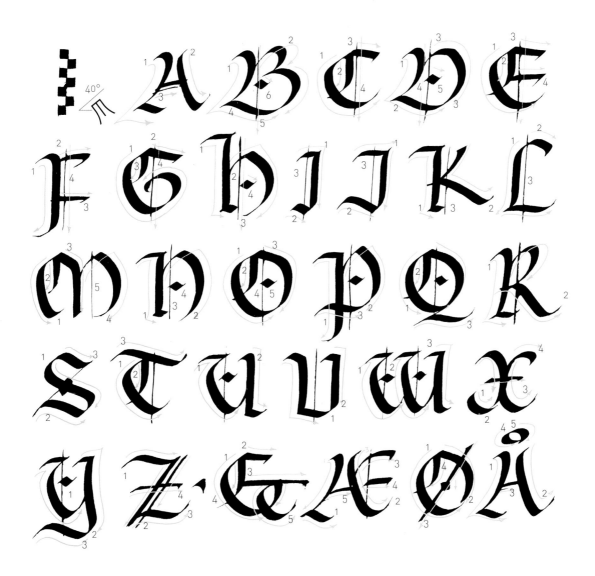

COMMON MISTAKES

Mistakes with Gothic mainly involve lack of balance, or nonuniformity in design of the groups of letters. The thin stroke is optional, as is the diamond.

Right-hand stroke is too upright, making a narrow letter.

Left and right strokes are unbalanced in width.

Top bar usually has a jaunty slope.

Top sags and looks depressed.

Bottom stroke should curve around to balance the top.

Too narrow – make it more rounded.

Joints at the base are more Uncial than Gothic and do not match other letters.

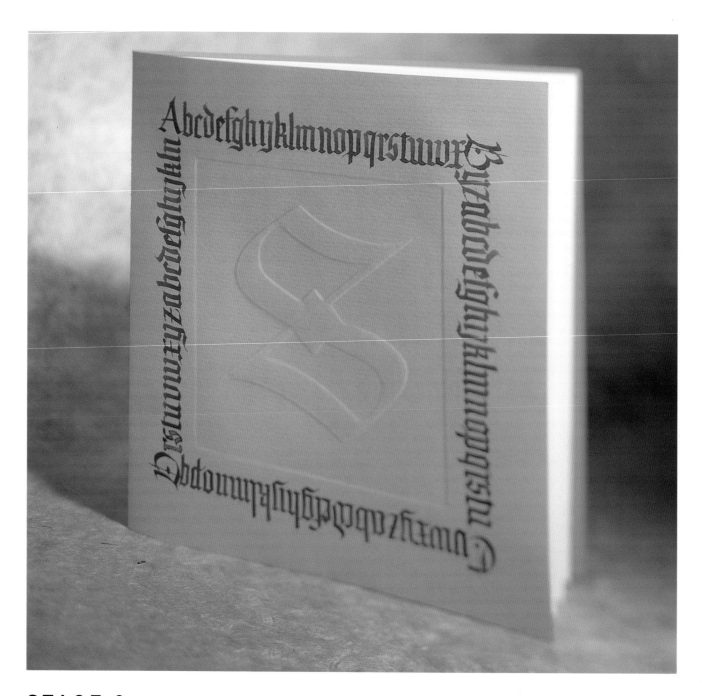

STAGE 3: Project

EMBOSSED NOTEBOOK

Embossing a letter on the cover of a handmade notebook makes the most of the elaborately decorative capital letters in Gothic script. For a gift, choose the recipient's initial and write an appropriate message around the edge. The method for embossing shown in the step-by-step pictures needs no specialist equipment—cardboard from a cereal box, a craft knife, and a knitting needle are the main items. The embossing is done from the back, pushing the paper into the cavity made by the stencil cut from the card. By working from the back, you avoid leaving any scratch marks from the embossing tool, in this case, a knitting needle. The use of textured paper will enhance the embossed image.

YOU WILL NEED

Automatic pen or large pen and ink

Soft pencil

Hard pencil

Thin cardboard

Thick colored paper

Plain white paper

Craft knife with new blade

Metal-edged ruler

Cutting mat or board

Gouache, or ink and dip pen

Large needle and cotton

Blunt pressing tool

Removable tape

Cotton ball

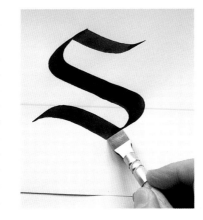

◆➊ LETTER PREPARATION

Write a large initial letter using an automatic or poster pen. Alternatively, write a smaller letter and enlarge it on a photocopier.

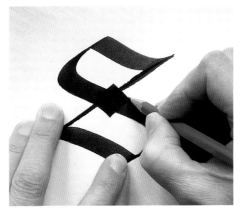

⚇ ➋ LETTER TRANSFER

Use a soft pencil to scribble across the back of the letter, then place the sheet onto cardboard and transfer the outline by drawing around it with a hard pencil.

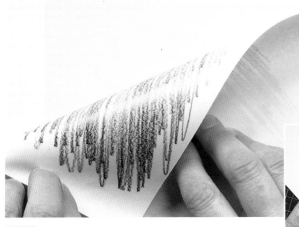

⚇ ➌ QUALITY CONTROL

Before completely removing the letter, carefully fold it back to see how well the letter has transferred.

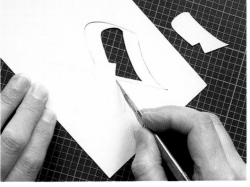

◆➍ CUT AND REMOVE

Cut out the letter from the card using a sharp craft knife on a cutting mat or board. The card with the hole makes the embossing; trim its edges to a square.

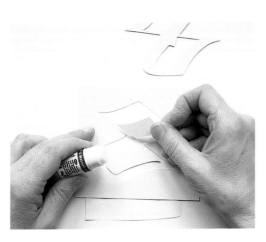

◆➎ POSITION AND PASTE

Where a letter has floating parts, as in an S, glue the trimmed card face down onto thin paper (so it reads in reverse). Fix the loose parts securely in position.

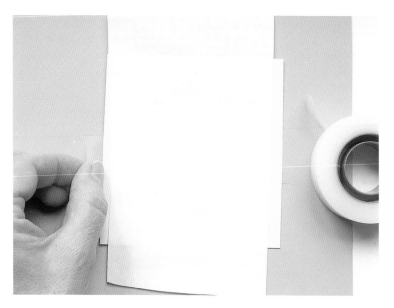

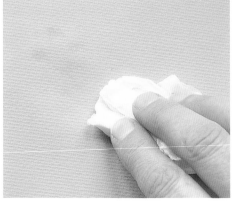

◀ 6 POSITION AND TAPE
Position the cardboard, reading the right way, onto the face of the paper to be embossed. Fix it with removable tape.

↑ 7 EMBOSSING PREPARATION
Turn over the paper to work from the back. Wet a cotton ball, squeeze it out, then rub it over the back to dampen the fibers.

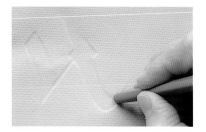

↑ 8 BLUNT PRESSING
Using a blunt, smooth tool, press gently all around the edges of the letter shape, to start to push the paper into the cavity.

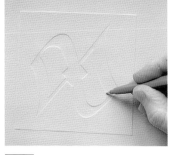

↑ 9 DETAILED PRESSING
With a finer tool, press gently into the edges of the cavity to define the detail, being careful not to push a hole in the paper.

◀ 10 CARDBOARD REMOVAL
Turn over and lift one corner to verify that the design has come through. Remove the cardboard carefully to avoid tape damage to the paper surface.

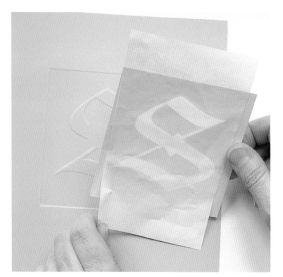

↑ 11 WRITING PREPARATION
When the paper is completely dry, rule pencil lines around the square ready for some writing.

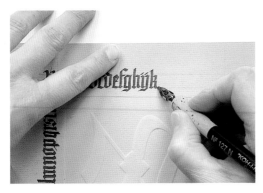

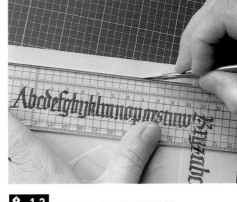

12 BORDER WRITING
Mix an appropriate color in gouache and write a suitable text around the edges. You could write an alphabet, as shown here.

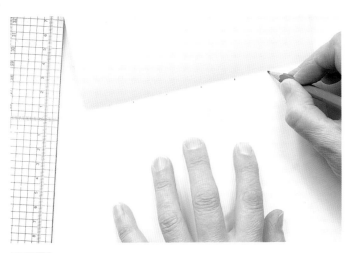

13 TIDY AND TRIM
Trim the paper using a craft knife on a cutting mat and a metal-edged ruler.

14 PREPARING THE INSIDES
Cut several sheets of paper for the insides of the notebook, slightly smaller than the cover. Fold the sheets and mark five sewing holes.

15 SEWING TOGETHER
Start sewing from the center hole inside, stitch all the holes but miss out the center as you go across to the other side. Finish with an inside knot at the center hole.

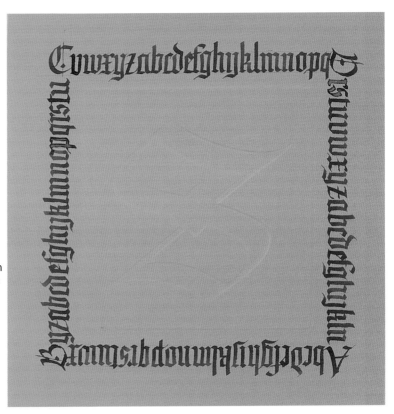

ITALIC HAND

STAGE 1: Getting started

The Italic hand is a delightful, flowing and rhythmical script, with springing arches and a comfortable forward slope. Italic evolved in Italy, during the Renaissance in the fifteenth and sixteenth centuries, from laboriously written Humanist minuscules (lower case letters). Executed quickly and with few pen lifts, the characteristics of this popular script are compression, slant and lift allowing for a wide range of variations.

PEN ANGLES
Italic is written with a pen angle of between 35° and 45°. Whichever you use, keep the angle constant.

45°

35°

LETTER HEIGHT
Italic is written with an **x** height of five nib-widths. Ascenders extend three nib-widths above the top line and descenders extend three nib-widths below the base line.

LETTER ANGLE
Italic is written at a comfortable slope of about 5°. The slope can be greater (up to 12°) but the pen angle would then need to be flatter (around 30°) to retain the thick and thin strokes.

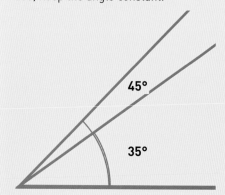

LETTER WIDTHS
The letters are based on a compressed oval and are about three nib-widths wide. This represents three-fifths of the **x** height.

PEN PATTERNS
Use the pen patterns to familiarize yourself with a pen angle of 40° and slope of about 5°. Try the vertical strokes first. The key shapes are **o**, which is an oval, and **n**. The **n** is an asymmetrical (unequal) oval because of the arch springing from the vertical two-thirds up the **x** height. Practice these patterns and springing arches until you achieve a rhythm in your writing.

Practice these shapes to become used to a constant pen angle of 40°.

Keep the angle of slope at 5°.

Try different heights.

ascender

Instead of a small serif at the base, try a curve.

Use these patterns to make these letters.

Make a downward stroke, then, without lifting your pen, return upward and make an oval arch springing out at two-thirds of the way up the stem.

Reverse this movement to make a continuous pattern.

These are the shapes that make up the letters **m**, **n**, **h** and **y**.

Make a good oval inside.

Holding the nib at 40°, make a curve from top to base line.

Reverse the shape.

Try writing them alternately.

These shapes form the oval letters.

Make a curve downward, then continue the curve back up to the top.

Try these two shapes. The second stroke is from right to left then down to the base line.

Joined together, these strokes will make these letters.

STAGE 2: The Alphabet

LOWER CASE LETTER STRUCTURES

The most important characteristic of Italic lower case is the smooth springing arch which occurs in all but the diagonal letters. You will appreciate this arch if you practice the letters **n** and **m**, followed by **h**, **k**, **b**, **p** and **r**. If you reverse the arch and try **u**, **a**, **d**, **g**, **q**, and **y**, you will begin to see the Italic family resemblance.

THE STRUCTURE	THE STROKES			THE GROUP

This key letter is achieved in one continuous stroke. Practice **n** and **m** alternately.

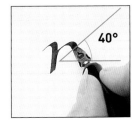 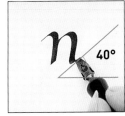 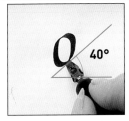

At a 40° pen angle, make an oval serif and bring the pen downward. Remember the 5° slant.

Without lifting the pen, go two-thirds of the way back up the letter stem and create an oval arch.

Continue the arch then bring the pen downward, parallel to the first vertical, into the serif.

mhr bpk

u represents the reverse pen action of **n**, and is also achieved in one stroke.

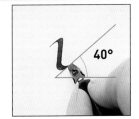 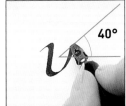 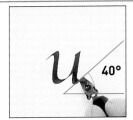

Make a serif and bring the pen down to the base line, making an oval shape at the bottom.

Using less pen pressure, push the line to the top, making a smooth, white shape inside.

Do not lift the pen, but pull downward to the base line and finish with a serif.

yad qg

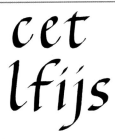

o establishes the width and weight of alphabet letters. The width is two-thirds of the **x** height.

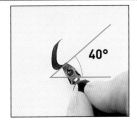 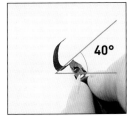 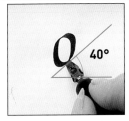

At a 40° pen angle, pull downward, curving at the top but keeping the side flattened.

Make an oval shape at the bottom and push the pen slightly upward.

Overlap the top. Curve upward then pull down, parallel to the first stroke, curving at base.

cet lfijs

A central axis at a 5° slant through the bottom point should divide the inside **v** shape equally.

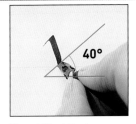 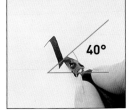 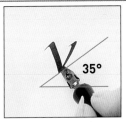

The width at the top should be as wide as **o**. Make a diagonal from left to right.

Before lifting the pen, push upward slightly as this makes joining easier.

Flatten the pen angle and make an oval serif, then pull downward to overlap the stroke at the base.

wy xz

THE ALHABET: LOWER CASE LETTERS

Italic letters, based on the oval shape, have a gentle forward slope and are made with minimum pen lifts. Some letters, **h**, **k**, **l**, **m**, **n**, **r**, and **u**, are created with one stroke. The curved letters have springing or branching asymmetrical arches which gives the script its graceful characteristics. Downstrokes should appear parallel and evenly spaced. The **x** height is five nib-widths, with ascenders and descenders extending another three nib-widths.

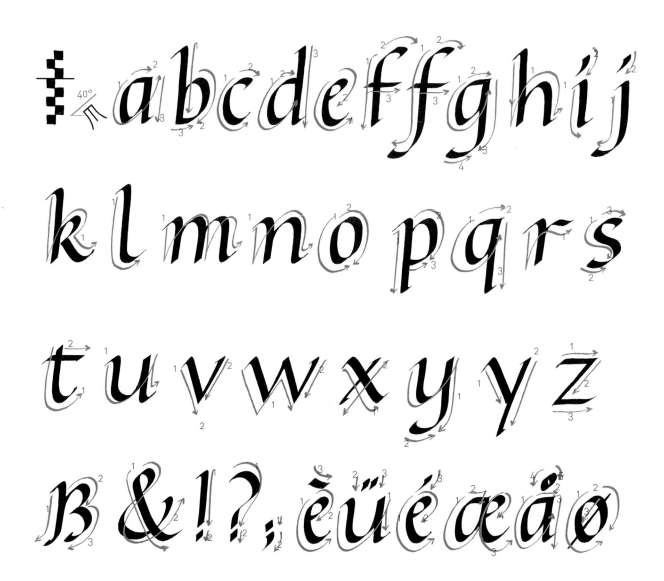

COMMON MISTAKES
The springing arches are a key characteristic of this alphabet. Do not begin the arches too high up the stem and do not make the oval shapes too rounded. Both these mistakes will make Italic look like a compressed Foundational hand and will spoil its narrow, elegant shapes.

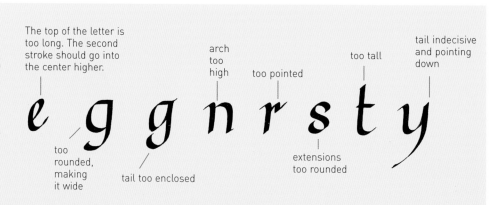

The top of the letter is too long. The second stroke should go into the center higher.

too rounded, making it wide

tail too enclosed

arch too high

too pointed

extensions too rounded

too tall

tail indecisive and pointing down

PRACTICING FORMS AND SPACING

Italic should appear evenly spaced with an equal area within and between letters. The width of the white or counter space of **n** should be the control measure. Space between words should be the width of the letter **o**. Visually balance the compressed white spaces within and between letters. The parallel downstrokes at a 5° slope and the neat, oval serifs complete the fluid appearance of this script.

LETTER SPACING

Good letter spacing
Here the spacing looks even. However, the space between the round letters **o** and **d** is slightly smaller than that between the straight letters **d** and **u**, creating a visual balance.

est modus

Poor letter spacing
Letter spacing is uneven: **e** and **s** have open areas within the letter shape and can be moved closer to compensate. The word spacing is too large.

Close space.

letters too close

Close space slightly.

est modus

Too wide: space should be visually equal to the width of **o**.

Too close: space should appear visually equal to inside of **u**.

Good letter spacing
Here the width spacing between words is correct. It is just big enough to enable the eye to distinguish between word and letter spacing.

in rebus

Poor letter spacing
The space between **i** and **n** is too small, emphasized by the overlarge word space which follows. The letter **s** at the end appears detached.

Allow more space.

Space between words should be no more than **o**.

too tight

Close space: should be visually equal to inside of **u**.

in rebus

slightly less space

WORD SPACING

To evaluate whether the spacing is correct or not, write a block of text. Uneven spacing will soon become apparent. The interlinear space is important: lines of writing that are too close create a dense texture and potential problems with overlapping ascenders and descenders. Too much interlinear space can make text look disjointed.

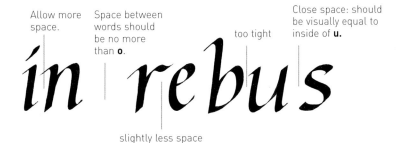

aequam memento rebu
in arduis servare ment
nil desperandum·nil d

CAPITAL LETTER STRUCTURES

Italic capital letters are compressed versions of Roman capital letters. The letter width differences are less noticeable because of the compression. Written at seven nib-widths high, they are shorter than the ascenders of lower case Italic, but the pen angle of 40° and the 5° slope are the same.

THE STRUCTURE	THE STROKES			THE GROUP

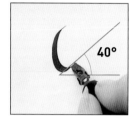
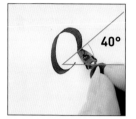
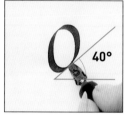

C D G QU

All circular letters are based on a compressed **O**, two-thirds the width of a Roman Capital **O**.

Begin at the top left and curve down, straightening the side and curving in to the center at the bottom.

Overlap neatly at the top, curve up, then straighten, parallel to the first side and curve in to center.

Overlap the strokes neatly at the base. The inside shape should be a regular oval.

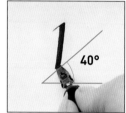
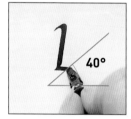
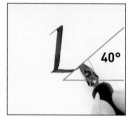

HIK NT

These straight letters are narrow, slanted Roman forms with the **N** having a slightly steeper angle.

At a 40° pen angle, make an oval serif and bring the pen down to the base line.

Start the second line slightly to the left to make the small serif.

This stroke goes along the base line, just over half the letter height long.

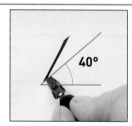
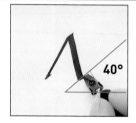
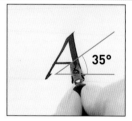

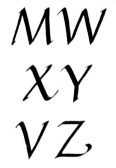

MW XY VZ

To maintain the 5° angle, a 5° axis should divide the center of **V** shapes equally.

At 40°, pull the pen down to the left and finish with a small, oval hook.

Join at the top neatly, overlapping the first stroke. Finish with a smooth oval serif.

The crossbar is just below halfway and made with a slightly flattened pen angle.

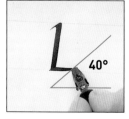
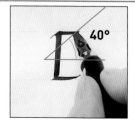
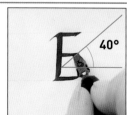

B F J PRS

These are the narrow letters with small bowls, which can usually be divided visually in half.

Move your pen down to the bottom and continue right along the base line.

Create a serif at the top and pull the pen along the line.

The center cross stroke should be the same as the top one. Its length is half the letter height.

THE ALHABET: CAPITAL LETTERS

Italic letters are based on Roman capital letter forms with the **O** shapes compressed by one-third. They are written with a slope on a slightly steeper pen angle, producing a lightweight, more flowing letter form. The rectangular letters are not compressed as much as the oval shapes, but should appear narrower.

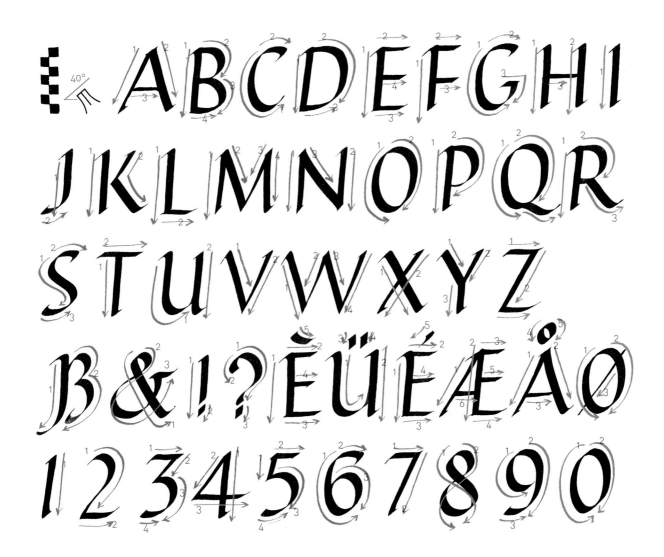

COMMON MISTAKES

The most common mistake is to make Italic capital letters too wide or too heavy. Do not make **H** or **N** wider than **O**, or **R** and **S** wider than **N**.

The second strokes of **C** and **G** should be flattened on the top, and **S** should not look like an eight, as in this example.

Middle crossbar too short: make it the same as top bar.

Steeper angle (50 - 55°) on legs of **N** makes them lighter. Make center stroke meet last stroke.

Top and bottom should be flatter.

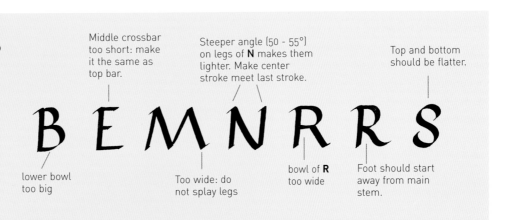

lower bowl too big

Too wide: do not splay legs

bowl of **R** too wide

Foot should start away from main stem.

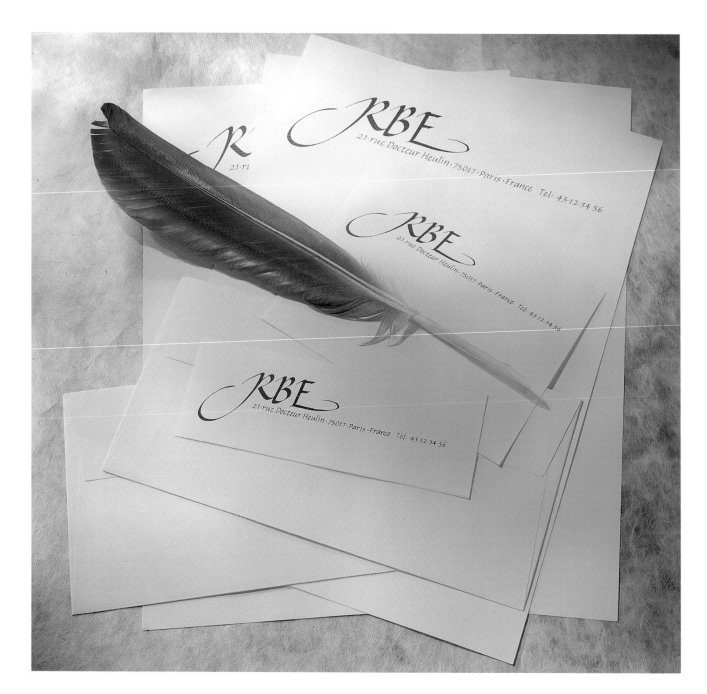

STAGE 3: Project

PERSONALIZING STATIONERY

Italic is a versatile script that can easily be adapted to create individual letter shapes for letter headings and monograms. This project is a simple design to do because the elements of the design are pasted together. As you become more skilled, more complicated letter heading designs can be created using the same method. Work with black ink or gouache on white paper. Write the words until they are correct, the paste the best written pieces onto clean paper. A monogram with the address incorporated below can be used to personalize your stationery: photocopy the design onto white or colored letter-sized writing paper. Alternatively, you can us it as a starting point from which to make business cards and compliment slips.

YOU WILL NEED

Pencil
Metal-edged ruler
Eraser
T square
Craft knife
Scissors
Layout paper
Dip pen with various
square-edge nibs
Black gouache
or calligraphy ink
Cartridge paper or artboard
Repositional glue
PVA or craft glue
Good quality writing paper

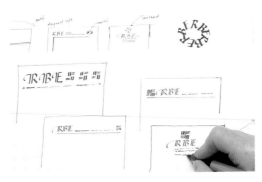

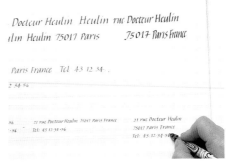

⬆ 1 THUMBNAIL SKETCHES

Do several practice sketches of your first ideas with a pencil or technical pen on layout paper. Try to create a good arrangement between the monogram design and the rest of the writing.

⬆ 2 WRITING TRIALS

Experiment with sizes for both the letter heading address and the monogram. Create a contrast but maintain a sense of balance between the different letter sizes.

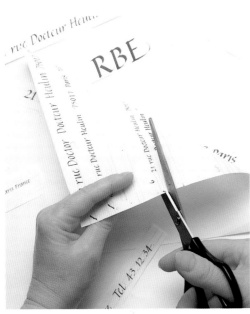

◆ 3 CUT AND POSITION

Choose the best practice piece you have written, and cut the various elements of the design into strips. Position the strips on your paper. Make the finished design around 50 percent larger than is required, so that it can be reduced on a photocopier or by the printer. This will remove any small mistakes.

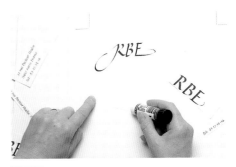

⬆ 4 PAPER PREPARATION

On good cartridge paper or artboard, mark out the size of your writing sheet. Be careful to position the corners correctly. Carefully measure the writing lines and spaces of the design on the paper, allowing plenty of space for margins. Glue the back of the strips.

ARTWORK 5 ◆ FINISH

Carefully place the glued strips of writing and the monogram into the correct positions. Use a T square or ruler to ensure that the lines are straight, then press firmly. Erase any guidelines. The artwork, which is a neat paste-up of the writing, is now ready to photocopy onto different colors of writing paper.

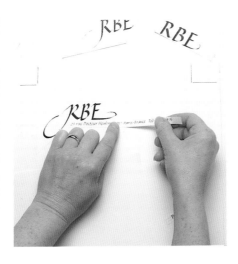

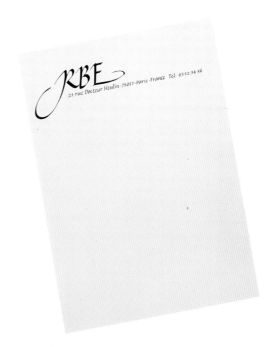

FLOURISHED ITALIC HAND

STAGE 1: Getting started

Calligraphic adornment of Italic letter shapes appeared during the Renaissance in Europe, when sixteenth century scribes delighted in decorating their writing. Every calligrapher enjoys flourishes and swashes, the flamboyant extensions and additions to letters. There are no rigid rules for flourishes, but they must appear to be an integral part of the letter, otherwise they will not look correct. Rely on your own sense of design.

PEN ANGLE
Pen angle is at 40° for flourishes on the main letter shape. Extensions or flourishes on the ascenders and descenders will be easier to do if you flatten the angle of the nib to 30°, or even less, to allow you to sweep into and out of the shapes.

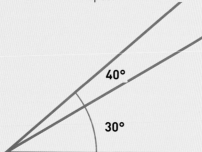

LETTER HEIGHT
Flourished Italic is written at the same five nib-width height as Italic. The ascenders are normally three nib-widths extra, but can be as high as space and design allow.

LETTER ANGLE
Flourished Italics, like formal Italics, are written at a 5° slant.

on

LETTER WIDTH
The width of the letters is about two-thirds the **x** height, or three nib-widths.

nhp

PEN PATTERNS

The pen will dictate some of the movements you can use to make flourishes. Pushing the pen upward and to the left will not work, but pulling the pen downward to the left or right will flow well. Most flourishes should be seen as a lead-in to or lead-out from the letter form. Below are some simple movements with which you can begin.

Hold your pen at 40°. When doing these strokes, hold the pen loosely and let your hand flow into the shapes.

Try this shape, moving the whole arm as you write.

Begin with a 30° nib angle at the top, twisting to 40° going downward on the stem.

These shapes will give you **f**, **l**, **h**, **b**, **k**.

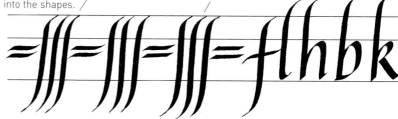

Try making this loop in one stroke. You will find it easier to do quickly.

Try this movement using the whole arm.

Now try these letters.

This pattern is the basis of the round letters. Keep your pen at 40°.

Try some complicated shapes. The flourish coming from the **e** is done at speed. Do not hold the pen tightly.

These patterns will enable you to make the small shapes with ease.

Add the tail of the **g** using a quick arm movement.

Try to build confidence doing these letters: the results are usually better.

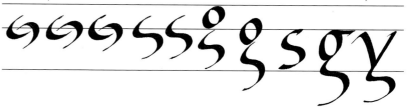

STAGE 2: The Alphabet

LOWER CASE LETTER STRUCTURES

Begin by learning some basic flourishes. Rule your lines as for the Italic hand, but leave greater spaces between the tramlines. Practice the letter shapes with a pencil first to familiarize yourself with their structures. Then try with a pen. Make sure that you retain the correct shape of the Italic letter form.

THE STRUCTURE	THE STROKES			THE GROUP

 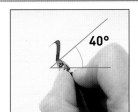 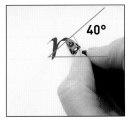 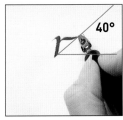 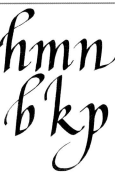

These are the arched letters. Create a selection of alternative flourishes for all letters.

With a 40° pen angle and whole hand movement, lead the pen into the main stem.

Continue down and move back up, then spring from the stem at two-thirds of the way up.

Moving quickly, finish the **r** shape and turn the pen onto the left side of the nib to make the upturn.

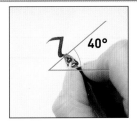 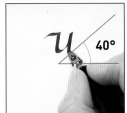 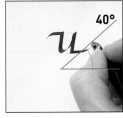 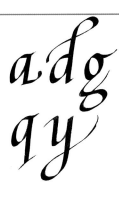

The letter **u** is the underlying shape of this group. You can extend only the serif.

Elongate the serif into the main stroke down.

Without lifting the pen, continue up to the top line, then back down to the base line.

The elongated serif can be a continuation of the letter stroke or added separately.

 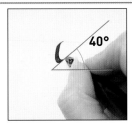 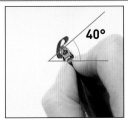 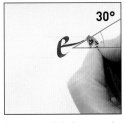 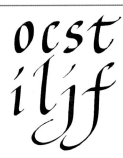

The cross stroke used for **e** can be used in the same way for **f** and **t**.

Pull the pen downward to make an oval with straight sides, curving at the bottom.

Overlap at the top and make an oval bowl, pulling into the letter. Do not lift the pen.

Pull out, slightly upward, flattening the pen angle and turning the pen onto the left side for the end.

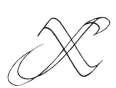 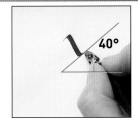 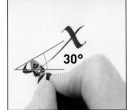 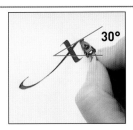

These small, simple flourishes can be extended or developed more.

Make a generous serif, pull down diagonally and finish with a serif.

With a flattened angle, make a serif at the top and pull to the left in a sweeping movement.

Add the top right-hand serif to finish.

THE ALHABET: LOWER CASE LETTERS

Examining historic flourishes from scribes such as Arrighi, Cantaneo and Vesparianio Amphiareo will inspire you, but do be aware of the many innovative calligraphy and lettering artists producing designs today. The possibilities of flourishing are endless and fun. Try the alphabet below, using the first **h** flourish on **k**, and the **a** serif on **n**.

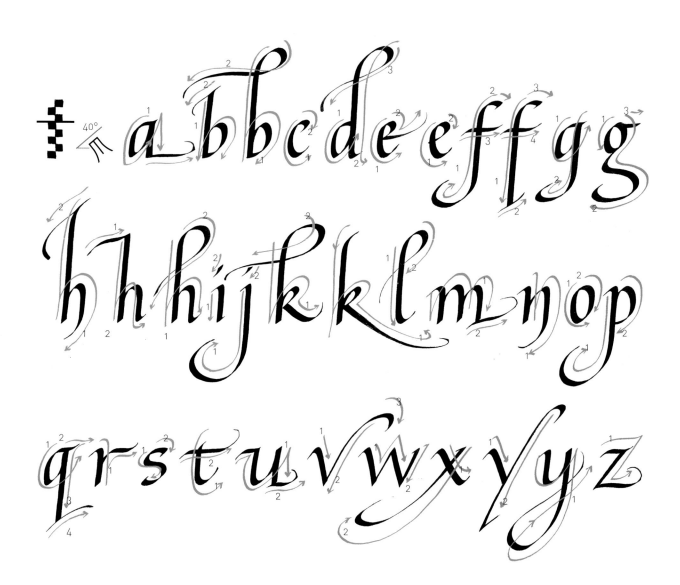

COMMON MISTAKES

The most usual mistake is to make the flourishes too mean. The flourishing action uses the whole arm. Find yourself a large sheet of paper and practice making sweeping movements with your pen. Be careful, in your enthusiasm, not to lose the basic oval Italic letter forms.

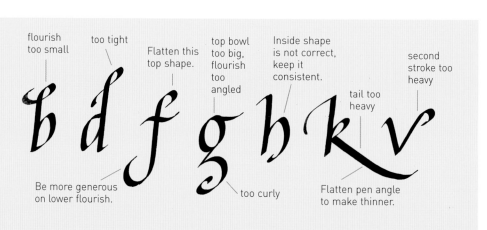

flourish too small

too tight

Flatten this top shape.

top bowl too big, flourish too angled

Inside shape is not correct, keep it consistent.

second stroke too heavy

tail too heavy

Be more generous on lower flourish.

too curly

Flatten pen angle to make thinner.

PRACTICING FORMS AND SPACING

Letters should be spaced as for the Italic hand, with the area inside equal to the space between. The distance between lines should be increased to accommodate any tall or wide flourishes. Use a pencil to plan the direction and route of extensions on ascenders and descenders. It is important to make sure that the writing retains a sense of spaciousness around it. Flourishes will not work if they are cramped or look contrived.

LETTER SPACING

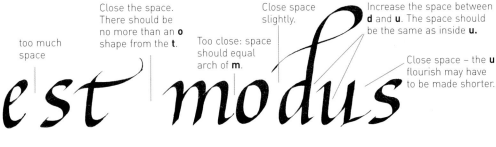

Good letter spacing
There is equal space in and between letters, with an **o** shape space between words. The flourish is generous and not too heavy.

too much space

Close the space. There should be no more than an **o** shape from the **t**.

Too close: space should equal arch of **m**.

Close space slightly.

Increase the space between **d** and **u**. The space should be the same as inside **u**.

Close space – the **u** flourish may have to be made shorter.

Poor letter spacing
There is too much space between **e** and **s** and a very large word space. In text with flourishing added, this would look very uneven.

Good letter spacing
Again the spacing is even in texture. The flourish on the letter **b** has been made to fit the word space, which pulls the line together.

Increase space to match inside of **n**.

Too much space: shorten cross stroke to reduce space.

Close fractionally.

Close space.

Poor letter spacing
Spacing here is erratic, with **i** and **n** too close. The letter **r** in **rebus** is out on its own, leaving the word **ebus**.

WORD SPACING

The interlinear space is larger in this text to allow for the flourishes. Note that the first capital **N** has been moved along the line to accommodate the flourishes. A larger space has been left at the end of desperandum to allow for the extended serif on **m**.

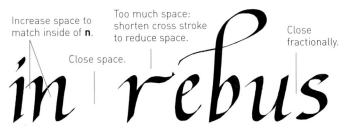

CAPITAL LETTER STRUCTURES

Flourishes or swashes must appear to be an integral part of the letter. Begin with the basic shape of the letter, leading in with an extended serif and finishing with an extension. Keep it simple. As you gain confidence and speed, try out other ideas: there are many variations of swashes for each letter.

THE STRUCTURE	THE STROKES			THE GROUP

Remember the Italic proportions of the letter **D**. Add swashes in pencil first to see if they work.

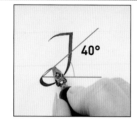

Bring the pen down and into the bottom stroke.

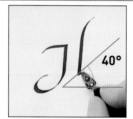

With a slightly flattened pen angle, make a curve. Pull from left to right to create the swash.

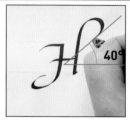

Be vigilant about the oval shape inside the **D** when you curve the pen down to meet the bottom stroke.

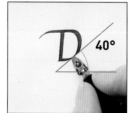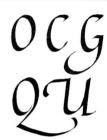

O C G Q U

Some of these letters can accommodate several flourishes, especially when used decoratively.

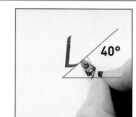

Make the first stroke in one movement, using the whole arm. Begin from the top left.

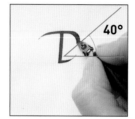

The right-hand stroke is also one movement downward, finishing with a serif.

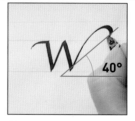

Sweep the cross stroke slightly upward with a flattened pen angle, and add an extended top serif.

K J L T N

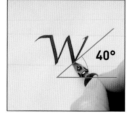

The flourish on **W** is simple and restrained, but look at the possibilities of **A**, **M** and **X**.

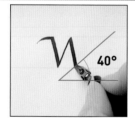

Do this pen stroke in one movement, stopping only briefly at the beginning of **W**.

Add a serif and right-hand descending diagonal. Be sure the lines meet at the base.

Alternatively, bring the pen upward from the bottom, sweeping into a curve at the top.

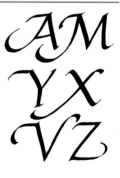

A M Y X V Z

Extensions can be made more complicated once you have mastered these simpler ones.

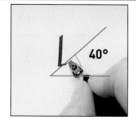

With one stroke, pull to base line, shape the corner and pull into the bottom curve of the **B**.

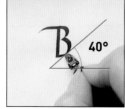

With a flattened pen, make a long flourish and curve into each bowl shape. Overlap at the base.

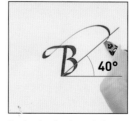

At the beginning of the top serif, overlap the stroke and push the pen upward to the right.

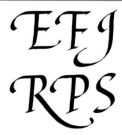

E F J R P S

THE ALHABET: CAPITAL LETTERS

Flourished or Swash Italic capital letters, based on Roman capital letters, have simple extensions. Swashes create a very fluid letter movement, making these letters excellent for poster writing. Written at seven nibwidths, the letters need plenty of space around them. A swash should be a simple flourish that is not too ornate.

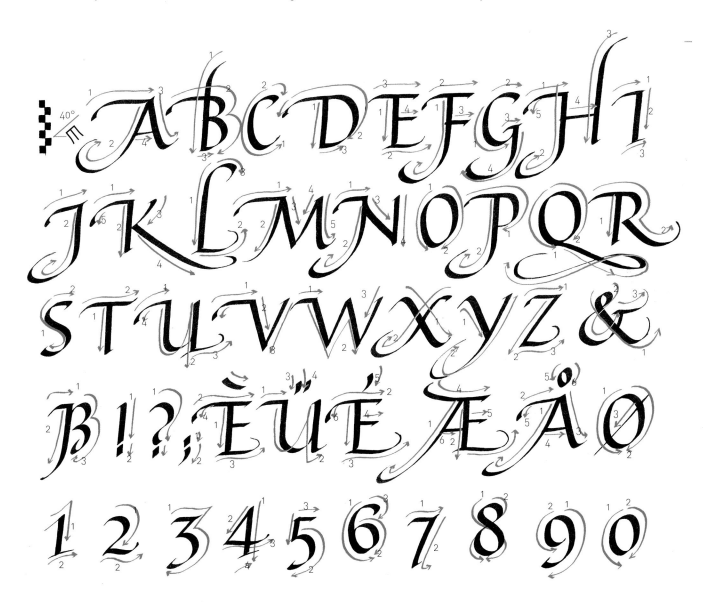

COMMON MISTAKES

Making too many swashes or flourishes is the worst mistake, as it alters the whole character of a piece of writing. The letter **R** here could be a **K**, and **M** looks very heavy and clumsy. Try not to make cross strokes wavy, as in **T**, and keep shapes open rather than curled and tight.

C is difficult to flourish as it can look like an **E**.

Too many flourishes makes a letter too ornate and heavy.

Do not dip cross stroke: it should be straight, not wavy.

top bowl too small

too large

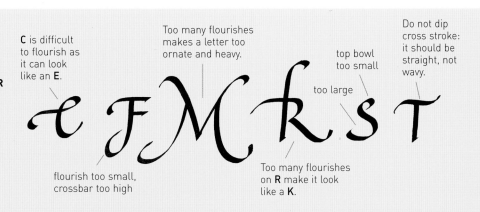

flourish too small, crossbar too high

Too many flourishes on **R** make it look like a **K**.

STAGE 3: Project

MAKE A BOOK

A handmade book is a very personal object to make and a lovely gift to receive. Before making any decisions on color and design, carefully consider the purpose of the book and for whom it is being made. The contents (text and illustrations), number of pages, and size are also factors that should influence the finished design. Wrapping paper, marbled, or textured paper can be used for the covers to make the book more unique. Always make sure that there are two plain pages at either end of the text to allow for gluing the book to the card covers. There are many different ways you can illustrate a book of this kind. Stamp or stencil designs can be used or you could try tracing your images from photographs or books.

YOU WILL NEED

Pencil
Metal-edged ruler
Eraser
T square
Craft knife
Scissors
Paint palette
Dip pen and square-edge nib (size 2½)
Layout paper
Bone folder
Pastel paper (2 or 3 colors)
Cardboard
Gouache paints
Mapping pen
Brushes
PVA or craft glue
Ribbons

◀●1 THUMBNAIL SKETCHES

Make thumbnail sketches in pencil of your ideas and possible layouts. Then practice some initial writing and color ideas.

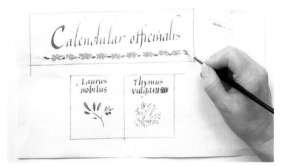

♟2 WRITING TRIALS

Develop the writing and decide on the pen size (in this case, square-edge nib, size 2^{1/2}) and the size of the finished book.

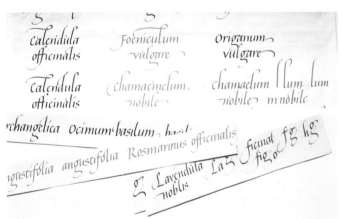

●●3 MOCK-UP

Make a mock-up of the concertina book to obtain a clearer idea of the layout and ruling plan, and to determine if any changes are needed. Measure the page size and score with a bone folder, or a similar instrument, to mark each individual page width. In this case, the page size is 4^{3/4} in x 6^{3/4} in (121 mm x 171 mm). Cut the pages into long strips.

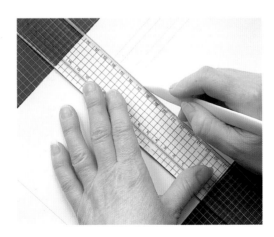

♟4 TRIAL ASSEMBLY

Join together the lengths of paper. Allow an extra 1/2 in (13 mm) on the last page as an overlap to glue pages together at the back. Leave two pages at the front and another two at the end of the book on which to glue the covers. This book has two plain pages at the front, nine written pages and two plain pages at the back.

◆● **5** **TRIAL PASTE**
Paste the text onto the pages in the correct positions. Add the separate squares of paper so that they form a good balance. Try different colors and ideas at this stage to be sure of your design. Add your illustration ideas.

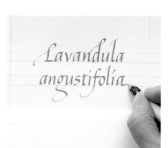

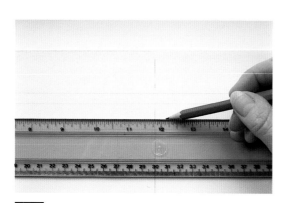

✦ **6** **CHOOSE PAPER**
When you are ready to do the finished copy of the book, choose good quality paper, such as the smooth side of pastel paper. Measure the pages as before, and rule your writing lines accurately.

◆● **7** **WRITE THE TEXT**
Write the text carefully in Flourished Italic, making sure that you leave adequate margins. It is a good idea to fold your practice sheet beneath your writing to use as a guide.

●◆ **9** **ILLUSTRATIONS**
Add the illustrations. If you prefer, you can trace the illustrations, paint them onto separate squares then glue them into place.

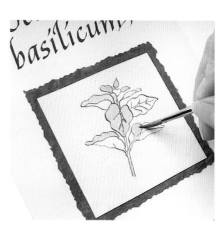

✦ **8** **CUT AND PASTE**
Cut your colored squares accurately. For this project, serrated scissors were used to give a torn look to the paper. Glue the squares into position with PVA or craft glue.

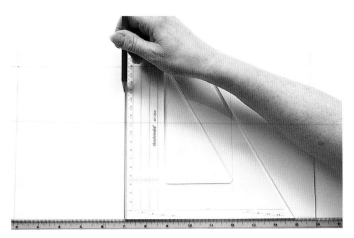

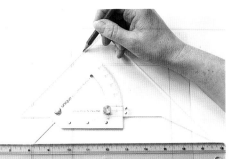

◆ 10 CUT THE COVER

Once the contents are finished, you need to add the hard cover. Cut two pieces of cardboard that are 1/4 in (5 mm) bigger all around than the page. In this case, the cover measures 5¼ in x 7¼ in (130 mm x 180 mm).

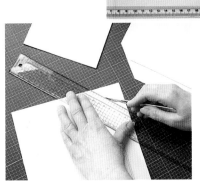

⬙ 11 COVER PAPER PREPARATION

Measure paper to cover the outside of the cardboard, adding 1 in (25 mm) all around to turn inside. On each corner, mark a 45° angle, which, when cut away, will enable the folded corners to meet neatly inside. Score the lines where the folded edges will be and trim the corners.

⬙ 12 FOLD AND STICK

Fold the paper cover over the cardboard, pressing the edges firmly to ensure a good fit. Glue into position.

◆ 13 FINISHING TOUCHES

Finally, glue the ribbon on the inside of the cover, 1 in (25 mm) from the edge, and glue the first plain page of the book on top, to hide the ribbon and the folded edges. There should be a space allowance of 1/4 in (5 mm) all around the inside of the cover. Repeat for the back cover.

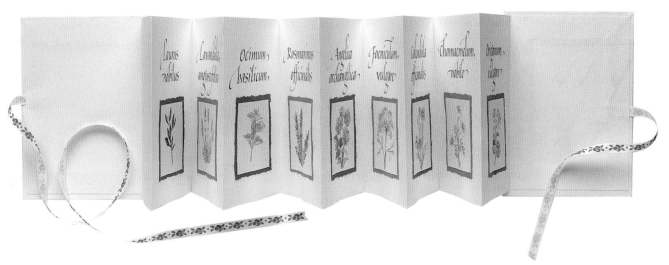

BÂTARDE HAND

STAGE 1: Getting started

The Bâtarde lower case hand has similarities to Gothic and to Italic, so experience with both of these can be helpful. Bâtarde is written with some pen twisting so, unlike most hands, you do not keep to one constant pen angle. Choose a pen which will not dig into the paper when you make the up-and-over strokes.

PEN ANGLE
This script uses some pen manipulation but is based primarily on an angle of 35°. Twist onto the edge of the nib to make the hairline strokes.

35°

LETTER HEIGHT
These very shallow letters are written at three nib-widths high. Measure by making squares with the nib, as shown, and rule tramlines.

LETTER ANGLE
Bâtarde letters slope slightly, to about 5° from the vertical.

LETTER WIDTH
The letters are a combination of pointed and curved letters, matching a fairly narrow **o**.

PEN PATTERNS
Follow these patterns, repeating many times until you can do them with confidence. Several involve an upward sweep where light pressure on the pen is important. Increase the pressure on the downward stroke. The patterns are component parts of letters, but many can serve on their own as border patterns.

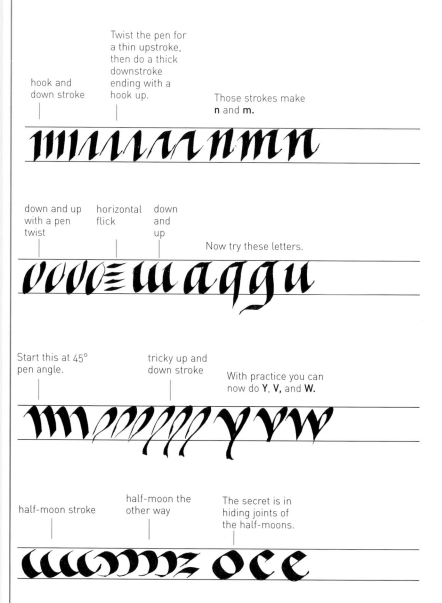

hook and down stroke

Twist the pen for a thin upstroke, then do a thick downstroke ending with a hook up.

Those strokes make **n** and **m**.

down and up with a pen twist

horizontal flick

down and up

Now try these letters.

Start this at 45° pen angle.

tricky up and down stroke

With practice you can now do **Y**, **V**, and **W**.

half-moon stroke

half-moon the other way

The secret is in hiding joints of the half-moons.

STAGE 2: The Alphabet

LOWER CASE LETTER STRUCTURES

Bâtarde letters have overlapping joints that branch out from or into the main stem, fairly like an Italic formation. Most arches are asymmetric and pointed, and diagonal letters have a vigorous swing in the right-hand stroke. Hairline strokes are made by twisting and skimming on the edge of the pen.

THE STRUCTURE	THE STROKES		THE GROUP

The arch branches out from around halfway up the stem, and makes a pointed corner.

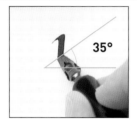

At a 35° angle, make the serif with a sideways movement, then pull down to the base line.

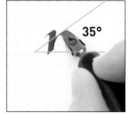

Push upward in a smooth curve, emerging from around halfway up he stem.

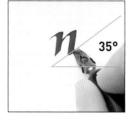

Pull down to the base line and make a gentle lift at the end.

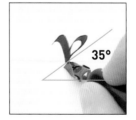 *(mrbk hp ijfl)*

Note where the arch joins in **a**, and look at the inside triangular shape.

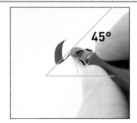

Pull down at 35°, then twist the pen slightly for the upward diagonal stroke.

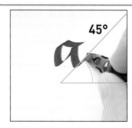

Put on the lid of the **a** with a slightly curved stroke.

Make a downward stroke that pulls away from the vertical slightly.

(qug t)

The down section of the up-and-over stroke is what defines the right-hand side of the **v**.

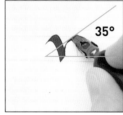

Make a hook serif, then pull the pen diagonally to the base line.

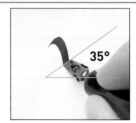

By twisting the nib slightly, make a hairline upward stroke.

Pull down and sideways, ending on a hairline stroke by skimming on the pen's edge.

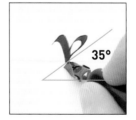 *(rwx 3)*

The letter **e** is related to **o**. It has a backward lean, and very little pen manipulation.

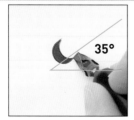

Make a half-moon shape with the pen at 35°.

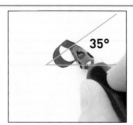

Make a flattened top stroke, joining the half-moon seamlessly.

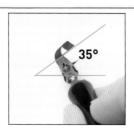

Move the pen diagonally, still at 35°, to achieve a thin finishing stroke.

 (codð)

THE ALHABET: LOWER CASE LETTERS

Bâtarde letters originated in fifteenth century France. They are mostly wide, with low branching arches and some pointed, some curved forms, making a less than uniform, but historically correct, alphabet. The pointed ends of **f**, **p**, **q**, and some of the branches are achieved by pen twisting. Hairlines are made by twisting the pen or skimming on the nib's edge.

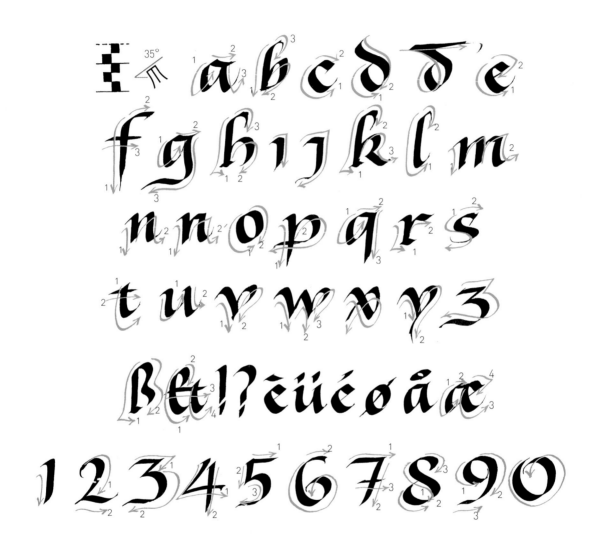

COMMON MISTAKES

Lack of observation of the halfway branching will spoil the handwritten feel of this flowing hand. Do not make ascenders too droopy, nor overemphasize the end strokes.

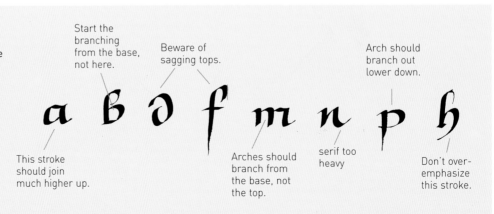

Start the branching from the base, not here.

Beware of sagging tops.

Arch should branch out lower down.

This stroke should join much higher up.

Arches should branch from the base, not the top.

serif too heavy

Don't over-emphasize this stroke.

PRACTICING FORMS AND SPACING

This script has an easy, flowing style which needs care in spacing to preserve the vitality and rhythm. Always look at the white spaces both within each letter and between them, to avoid pockets of dense text or open areas. Turn the page upside down to see more clearly the unevenness of the second and fourth lines below.

LETTER SPACING

Good letter spacing
Note how **s** and **e** have been put close together to avoid their adjacent spaces combining to make a wide blank. **o** next to **d** is difficult to balance.

Tuck **e** and **s** close together as they have their own spaces.

This word has even spacing.

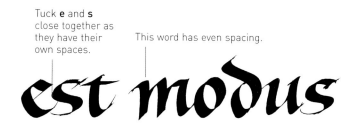

Poor letter spacing
Some letters here are too close, others are too far apart, and the final **s** has wandered away from the four bunched letters. The space between the words could be smaller.

too much space

The first four letters are too close and **s** is too far away.

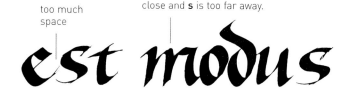

Good letter spacing
If all letters were vertical lines, it would be easy to recognize even spacing, but curves and open letters require optical decisions to be made.

Keep verticals evenly spaced.

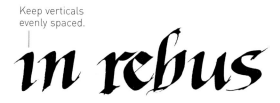

Poor letter spacing
The letters **i** and **n**, and **b**, **u**, and **s** are too close, and there is a gaping hole at **r**, which often causes problems unless the next letter is tucked under.

too close

Tuck the next letter close under **r**.

too close

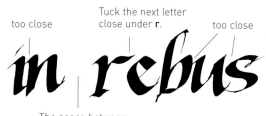

The space between words should only be about the width of an **o**.

WORD SPACING
Try to keep the space between words minimal, especially when the space between lines is this narrow. Otherwise, the words will seem to float.

The interlinear space is one and a half times the letter height.

The space between words is about the width of an **o**.

Aequam memento rebu

1

1.5

in ardus Servare ment

CAPITAL LETTER STRUCTURES

Bâtarde capital letters, in common with most decorative letters, are generally constructed with minimal pen lifts. Compared with Gothic capital letters, they are much less rigidly designed, with many resembling the lower case forms. Look carefully at the diagrams to see the inside shapes.

THE STRUCTURE	THE STROKES			THE GROUP

These are open, rounded letters. The first and second strokes do not overlap.

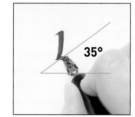
Make a half-moon stroke with the pen at 35°.

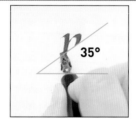
Starting at the top of the half-moon, pull down, then horizontally, with a curving sweep and small serif.

Make the final horizontal sweep and end in a small serif.

The up-and-over stroke branches from the stem with **R**, **K**, **P**, **F**, and **B**.

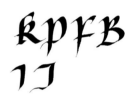
Make a serif, pull down, then pull across.

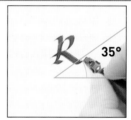
From the center of the stem, pull upward, looping back around beyond the stem.

Pull down for the final graceful sweep.

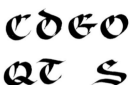

With **Y**, the upstroke is light, with the downstroke defining the right-hand side into the descender.

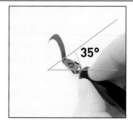
Pull down in a smooth, sweeping movement.

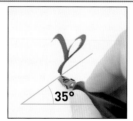
With lighter pen pressure and slight twisting, spring upward from the base.

Pull down in a gentle curve to define the right-hand side of the **Y**.

The letter **N** starts with a vigorous downward curve. The arch has a squared top.

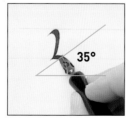
Like **R**, make a serif and pull down then across.

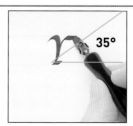
Pull up and out three-quarters of the way up, then pull across.

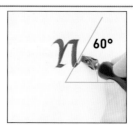
Pull down with a gentle lead-off stroke.

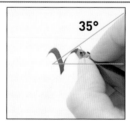

THE ALHABET: CAPITAL LETTERS

These are elegant, vigorously written, slightly forward-sloping letters, which complement the lower case. The pen angle does vary occasionally for achieving hairlines and points; the bases of **F** and **P** require a pen twist. Avoid writing whole words in these letters as they would be difficult to read.

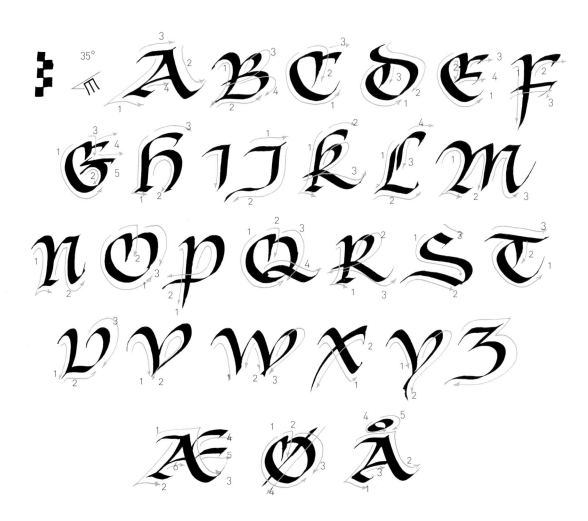

COMMON MISTAKES

Sometimes the branching stroke emerging from the stem is overlooked, losing that lively movement. Avoid droopy ascenders like **L**, strokes that are too thin, like **X**, and wrong stroke direction, such as **V**.

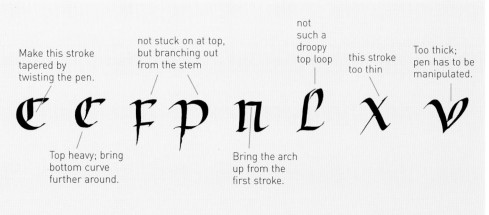

Make this stroke tapered by twisting the pen.

not stuck on at top, but branching out from the stem

not such a droopy top loop

this stroke too thin

Too thick; pen has to be manipulated.

Top heavy; bring bottom curve further around.

Bring the arch up from the first stroke.

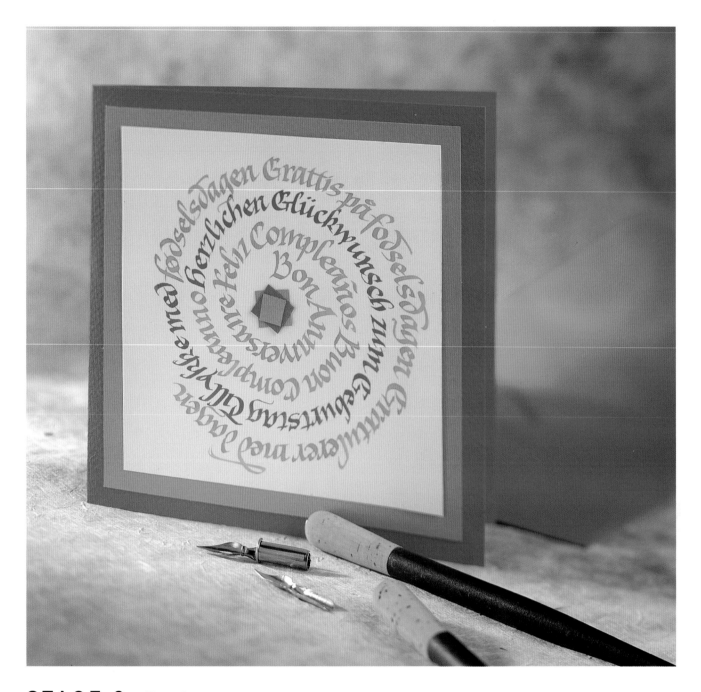

STAGE 3: Project

BIRTHDAY CARD SPIRAL DESIGN

This colorful and fun project shows you how to write in a spiral and introduces you to alternating colors in your writing. The chunky and cursive nature of the Bâtarde hand makes it a good choice for writing in a spiral on this unusual birthday card design. To personalize the card, you could include the recipient's name in the text. Or alternatively, if you are making a card to celebrate another occasion,.you could choose an appropriate quotation to mark the event or even a favourite poem. For variation in future card projects, instead of alternating colors, try starting with a dark shade of one color and graduate to a lighter shade as you spiral outward. There is no limits to the fun you can have with this design.

YOU WILL NEED

Practice paper
Good quality white paper
Colored paper
or thin cardboard
Gouache or inks
Dip pens
Compass
Ruler
Pencil
Craft knife
Cutting mat
Scissors
Glue

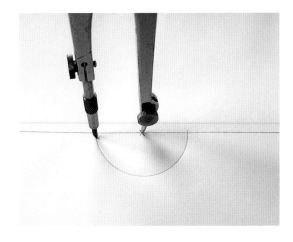

◆▬ 1 WRITING PREPARATION

Lightly rule a pencil line across the page. Open the compass to slightly more than twice the height of your intended writing lines and make a clockwise semicircle.

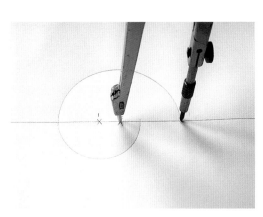

⚑ 2 WRITING PREPARATION II

Move the compass point to exactly midway along the line between the first point and semicircle, open it and continue clockwise.

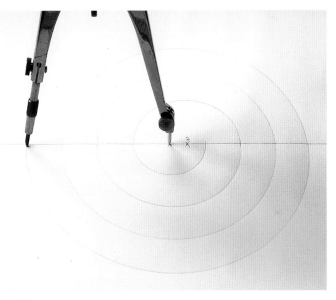

⚑ 3 WRITING PREPARATION III

Return to the first compass point, open the compass and continue clockwise. Repeat this procedure for several more turns. Mark the two points as one and two.

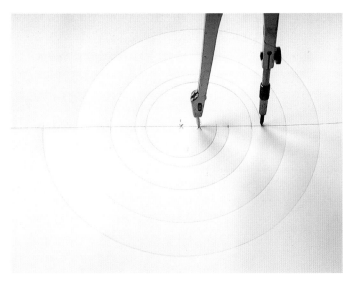

◆▬ 4 WRITING PREPARATION IV

Return to the beginning to repeat the procedure so as to provide a top line for the writing tramlines. Remember to start on the first compass point.

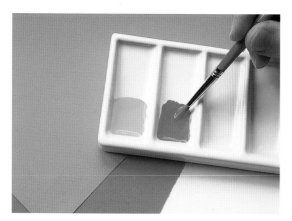

⚜ 5 COLOR PREPARATION
Mix two colors of gouache, or find two inks that match the papers you have chosen for the card.

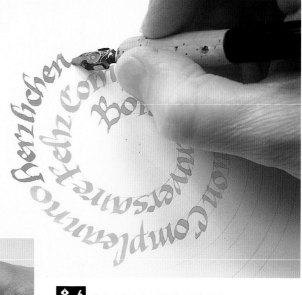

⚜ 6 SPIRAL WRITING
Start writing from the center, turning the paper as you write. Stop and leave to dry whenever you feel you might smudge the color. Change color and continue.

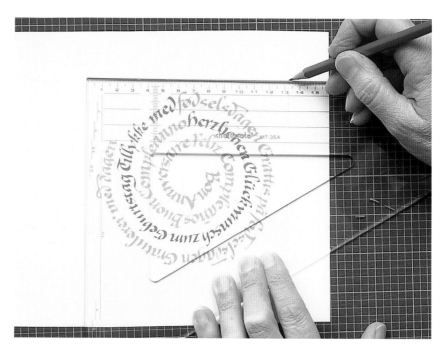

DRY 7 ⬥ AND TIDY
When the paint is thoroughly dry, remove the pencil lines with a soft eraser.

MAKING 8 ⬥ A SQUARE
Use a set square to measure from the center compass point and figure out how to obtain a square around the spiral.

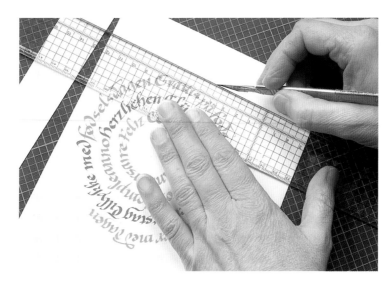

9 RULE AND CUT

Cut out the square with a craft knife and metal-edged ruler. Place the ruler over the work to avoid cutting into it.

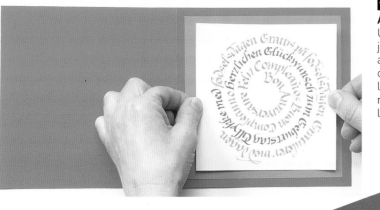

10 CUT AND PASTE

Use the square you have just cut to measure and cut a larger one from the colored paper. Then cut a large rectangle for the main card. Mount the layers together.

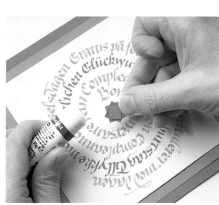

11 FINISHING TOUCHES

Cut some small squares from the waste colored papers. Glue them in the center, with each square smaller and offset from the square underneath.

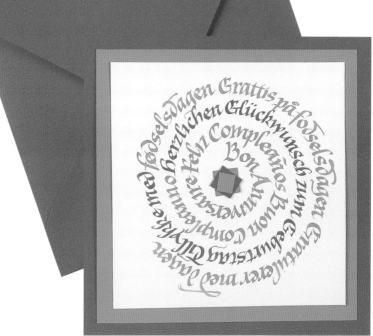

VERSAL HAND

STAGE 1: Getting started

The Versal hand is a capital hand, based on Roman capital letters, with the same measurements. The finest historical examples of Versals are in ninth and tenth century manuscripts, where they were used as headings or, singly, to denote the beginnings of verses. Both historical and modern Versals are made of compound pen **strokes**. Each vertical stem is drawn with three pen strokes: two outer strokes and a third to fill the center with ink.

PEN ANGLES
All downward strokes are made holding the nib horizontally (at 0°), as are the top and bottom serifs. Vertical serifs require an angle of 90°. Curved letters are created with a pen angle of 20°.

90°

20°

0°

LETTER SIZE
Each stem is made of three strokes and is therefore three nib-widths wide. The height of a letter is eight stem-widths, which is therefore 24 nib-widths high.

LETTER ANGLE
Originally used with formal scripts, Versals are usually written upright. Informal, contemporary Versals can be slanted or written without serifs.

LETTER WIDTH
Versals are based on Roman capital letter proportions. **O, Q, C, D** and **G** are circular outside with an oval inside. **A, H, N, T, U, V, K, X,** and **Y** letter widths are 3/4 their height. **B, E, F, L, P, R,** and **S** letter widths are 1/2 their height.

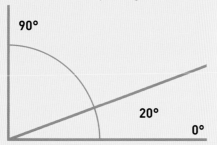

PEN PATTERNS
Follow the pen patterns below, changing the pen angle from vertical (90°) to horizontal (0°) as required. Each letter shape is constructed from individually drawn lines with added serifs. Each letter stem and curved stroke should be three nib-widths at its widest point otherwise it becomes too heavy.

Holding the nib horizontally (0°), draw a vertical downstroke.

Draw them closer. This takes practice.

Try two lines as close as this.

Holding the nib horizontally, draw two or three lines together, curving slightly to the right.

Fill the center with lines written at 0°.

Draw two downstrokes, curving inward very slightly in the center, to make a letter stem.

Add serifs to the top and bottom with a pen angle of 0°. Fill in the stem with a third stroke.

Do this letter the same way.

Add a crossbar.

Draw these lines from top to bottom, keeping one nib-width space between. Curve inward at the center.

Draw one complete line from the top left to the base line. Add a downward top stroke.

Draw from top to bottom.

Practice horizontal serif lines with the pen nib held horizontally.

Try the patterns again.

Fill in the letter stem each time with a third pen stroke.

The pen angle should be no more than 20°. Begin by drawing a curve from top to base line.

Try the reverse. Draw from top to base line.

Add a second line. You can see the form for the round letters.

Try the reverse.

Fill the space between the lines with a third pen stroke.

This letter is made in the same way, with the serifs on the right made with the nib at 90°.

Try some complicated strokes. Hold the nib at 20°.

Now hold the nib parallel to the base line for cross strokes. Turn your pen angle 90° to form a serif.

Try some small shapes.

The angle of the pen must change to achieve the correct shapes for these letters.

STAGE 2: The Alphabet

CAPITAL LETTER STRUCTURES

The pen should be held so that it makes the widest line for horizontal, vertical and diagonal strokes, and the thinnest line for serifs. Each letter is built by drawing separate strokes, using two or three strokes for the letter stems. Until you are confident, you may find it helpful to draw skeleton shapes with a pencil.

THE STRUCTURE	THE STROKES			THE GROUP

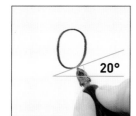
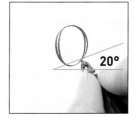
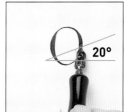

QCG DU

Hold the pen at a slight angle (20°) to make the four curves of **O**.

At a 20° pen angle, pull from the top to the base line, creating an oval.

Add a second stroke to each side of the **O**, with one nib-width space between pen strokes.

Fill in the space with a third stroke for each side.

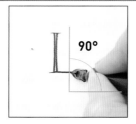
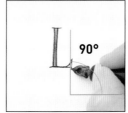
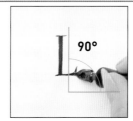

E F H KMT

With a 0° pen angle, draw two downstrokes, with a slight waist for elegance, one nib-width apart.

Use the same pen angle to add a top serif. Draw along the base with the pen at 90°.

With the pen at 90°, add a serif.

Fill in the stem and the small serif with the third strokes.

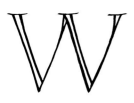
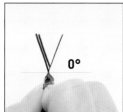
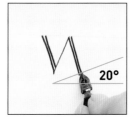
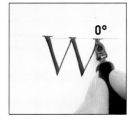

ANV XYZ

This letter comprises six pen strokes, plus serifs. Keep the diagonal stems parallel.

Draw the first diagonal with two downstrokes. Pull down on the next stroke to complete a **V**.

The third stem of the **W** should be parallel to the first. Each double stroke is 'waisted' in the middle.

Pull the last stroke downward. Add shaping to the second and fourth stems and add serifs.

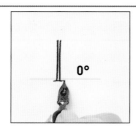
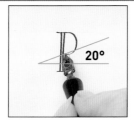
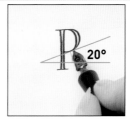

BRS I J

The letter **P** has straight and curved shapes. Remember the angle changes.

Holding the pen horizontally, construct the letter stem and add a bottom serif.

Starting at the top – including top serif - add the inside oval curve with a pen angle of 20°.

Add the outside circular curve with one nib-width space between the widest part of the pen strokes.

THE ALHABET: CAPITAL LETTERS

These graceful and adaptable capital letters, based on Roman capital proportions, will become easier once you have learned how and when to change pen angles and to build the shapes methodically. Versals can be used as headings or as single initial letters at the beginning of a piece of text. For a contemporary look, write them sloped with Italic lower case or without serifs. When well-executed, Versals look exceptionally good by themselves in a piece of work.

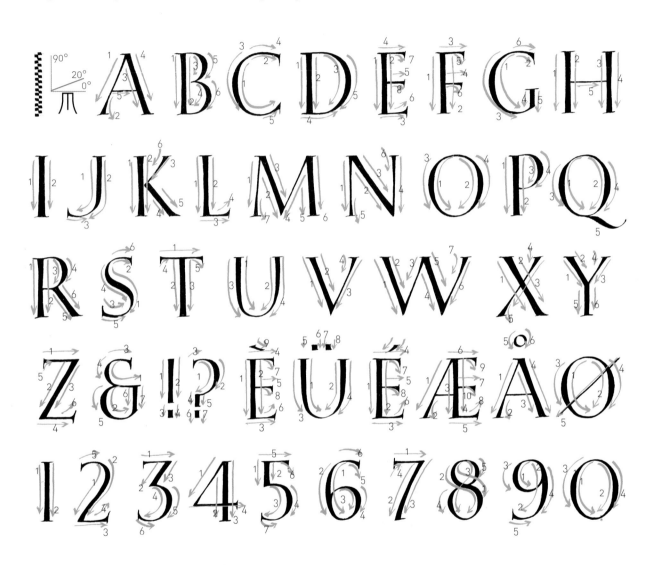

COMMON MISTAKES

Do not make the verticals too thick or heavy: remember that they are only three nib-widths wide. Remember to give the stem a waist, but with minimal curving on the downstrokes. Keep all serifs fine with the pen either horizontal (0°) or vertical (90°). Do not make the curves too thick at their widest points.

Do not curve the letter strokes too much, otherwise the shape becomes too heavy.

Keep inside shape oval, keep rounded on the base.

Do not splay the legs of **M**: it becomes too wide.

Keep downward stroke straight.

Do not make the bowl of **R** too wide. Foot starts farther from the stem.

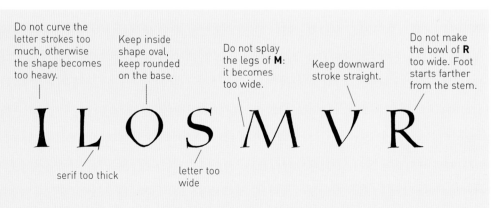

serif too thick

letter too wide

PRACTICING FORMS AND SPACING

Versal capital letters should be elegant and lightweight in character, and require generous space around them. The round shapes of **O**, **C**, **D**, **G**, and **Q** are oval inside. This white inner space should be reflected visually between letters to give an even texture. Interlinear space should generally be slightly more than the letter space to improve legibility (a third of the letter height is acceptable).

LETTER SPACING

Good letter spacing
The spaces between letters are visually comparable to the areas within the letters. There is slightly more space between words.

EST MODUS

Open space: too close.

too close

These spaces are even, but a little too close.

Too wide when compared with the space between **O** and **D**.

Poor letter spacing
The letters are cramped, making it uncomfortable to read on a long line, especially with the large spaces between words.

EST MODUS

Space between words should be equal to an **N** shape.

Good letter spacing
It is often difficult to balance spaces between open letters. As a control, try imagining the oval inside an **O** squashed and reshaped to fit between a letter. Would it be too big or too small?

IN REBUS

Space is too generous, close up.

Space between words is too wide, making reading difficult.

Two straight letters need more space.

This letter is difficult to space because of the open lower bowl. Close fractionally.

Poor letter spacing
There is twice as much space between **I** and **N** as there is between **E** and **B**. **REB** looks smaller and heavier than **BUS** because of poor spacing.

IN REBUS

too close

Too crowded, making letters look heavy.

WORD SPACING

To retain evenness and legibility in longer lines of text, the interlinear space must appear slightly wider than the space between letters. Short lines of text can be written closer together. Compare the interlinear space with the space between **M** and **E** on the first line. Turning written work upside down will enable you to review the problems of spacing.

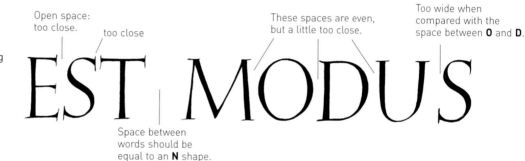

AEQUAM MEMENTO

REBUS IN ARDUIS SE

SERVARE MENTEM A

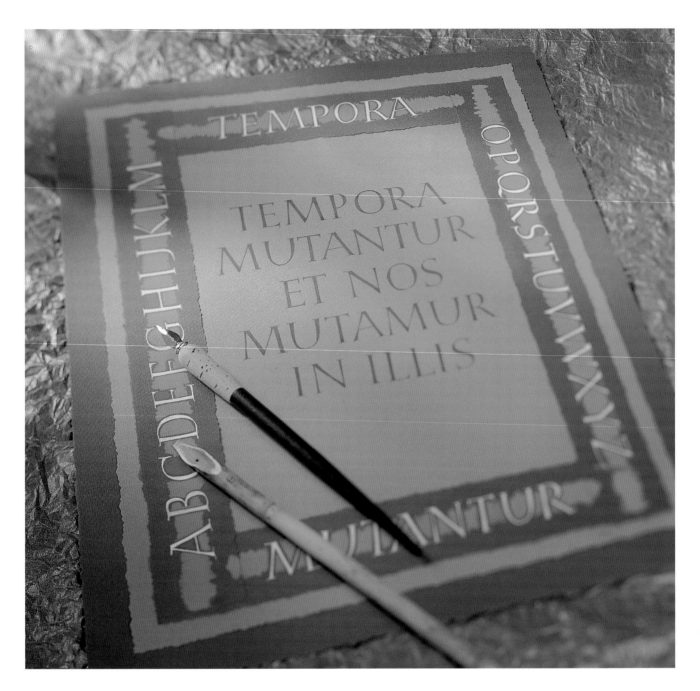

STAGE 3: Project

TORN PAPER DESIGN

A torn paper design is a fun way of making a broadsheet or panel without having to put all your writing onto one single sheet. It is an ideal way to experiment with different combinations of color and different ideas, altering or even changing them completely as you progress. There are many different papers that can be used to make this project, offering a variety of colors and textures. When choosing your paper first test the surface to make sure that you can write on it. Then take time to think through your idea thoroughly before cutting or tearing your paper—your design and layout will be just as important as the quality of your writing if you want to achieve a successful result.

YOU WILL NEED

Pencil
Metal-edged ruler
Eraser
T square
Scissors
Craft knife
Paint palette
Dip pen and nib (size 4)
Layout paper
45° set square
Paint brush
Gouache paints
Pastel paper (2 colors)

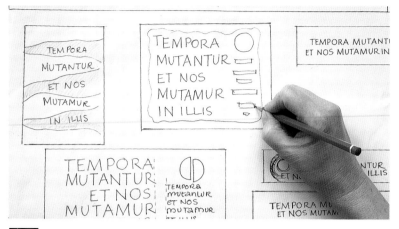

1 THUMBNAIL SKETCHES

Begin by drawing thumbnail sketches of your initial ideas. Draw layouts for your whole design, deciding whether it should be portrait (vertical) or landscape (horizontal).

2 WRITING TRIALS

Write the text with attention to letter form and line spacing. Try different weights of letters to find the most appropriate.

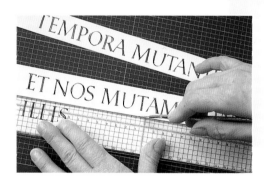

3 CUT AND POSITION

When you are satisfied with the letters, cut the lines into strips, removing any errors. Arrange the strips on a clean piece of paper to see if your design works.

4 PASTE

Make a final decision on your design. Paste the strips into position using repositional glue or small pieces of tape, so that you can change the position of the line if necessary.

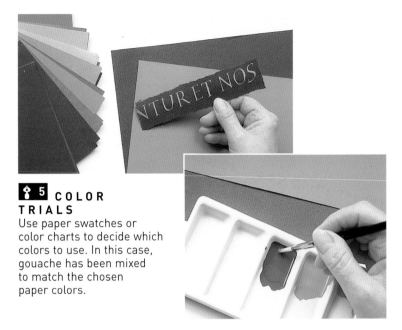

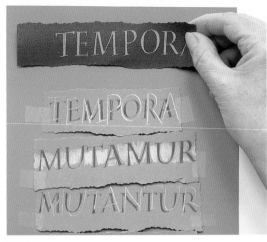

✒ 5 COLOR TRIALS

Use paper swatches or color charts to decide which colors to use. In this case, gouache has been mixed to match the chosen paper colors.

✒ 6 PAPER TRIALS

Buy enough paper to enable you to experiment with ideas before you attempt the final version.

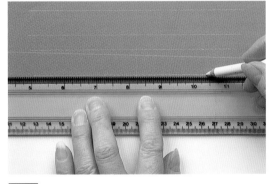

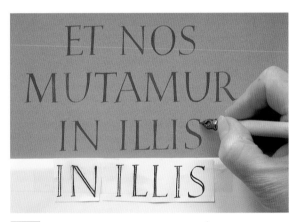

✒ 7 PAPER PREPARATION

When you are ready to do the final version, rule all your measurements accurately, using a sharp pastel pencil on colored paper.

✒ 8 WRITING PREPARATION

Place your practice sheet below or above your writing and use as a guide to prevent mistakes.

✒ 9 WRITING

Once you have completed the main writing, write the text for the rest of the composition, which will be added as strips.

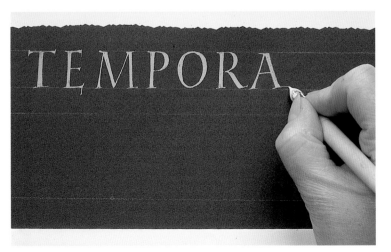

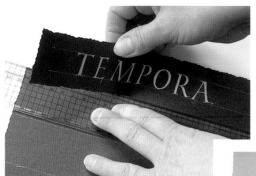

◆ 10 **CUT OR TEAR**
Cut or tear the strips to be added to the design. If they do not look right, do them again. In this case, the design would benefit from a wider top strip.

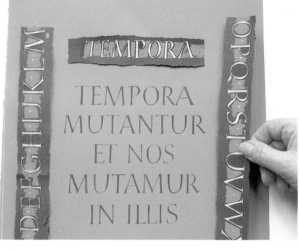

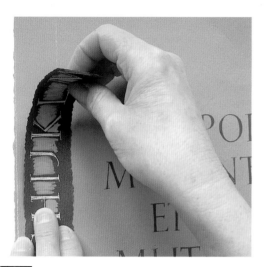

✦ 11 **PASTE**
Paste the strips into position with PVA or craft glue, leaving a small margin or border around the edge.

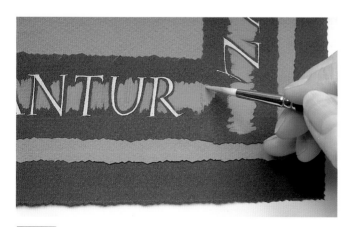

✦ 12 **FINISHING TOUCHES**
Finally, paint over the joints made by the strips of paper to complete the design.

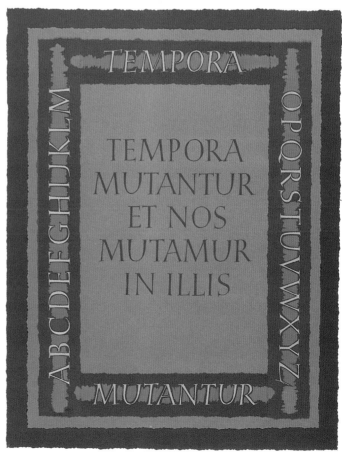

RUSTIC HAND

STAGE 1: Getting started

The historical Rustic capital letters, written from the first to the sixth century, were executed either with a square ended brush or pen. The narrow letters appear tall and elegant, yet with a vibrant, lively rhythm created by heavy diagonals and serifs. There are changes in pen angle on most of the letters,

PEN ANGLE
The downward vertical slope employs a steep pen angle of about 75° to 80° curved letters are made at 60° and diagonals and serifs use 50° and 45° angles. Letter stems are the most difficult, changing from 80° at the top to around 50° at the base.

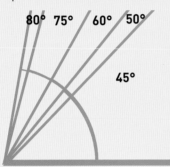

LETTER HEIGHT
Rustics are capital letters written at seven nib-widths high.

LETTER ANGLE
These capital letters are written upright.

LETTER WIDTH
The **O** is based on an oval, with other letters compressed to give continuity to shape and form. Some letters are only slightly wider than half the letter height.

PEN PATTERNS
These pen patterns are designed to help you understand the characteristic pen angles used for each group. It takes practice to write with thin uprights, thick cross strokes, and serifs.

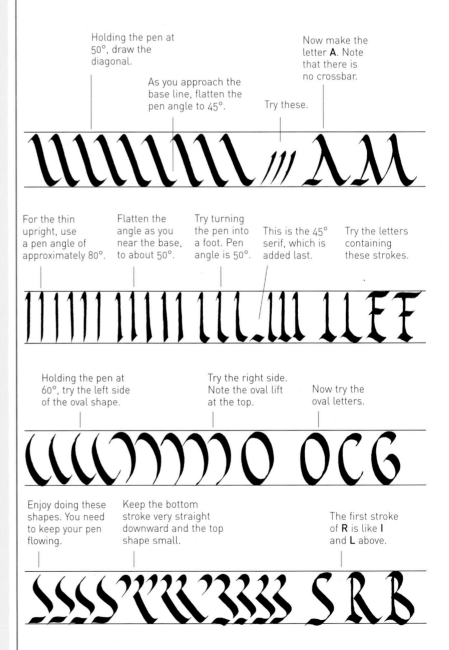

Holding the pen at 50°, draw the diagonal.

As you approach the base line, flatten the pen angle to 45°.

Now make the letter **A**. Note that there is no crossbar.

Try these.

For the thin upright, use a pen angle of approximately 80°.

Flatten the angle as you near the base, to about 50°.

Try turning the pen into a foot. Pen angle is 50°.

This is the 45° serif, which is added last.

Try the letters containing these strokes.

Holding the pen at 60°, try the left side of the oval shape.

Try the right side. Note the oval lift at the top.

Now try the oval letters.

Enjoy doing these shapes. You need to keep your pen flowing.

Keep the bottom stroke very straight downward and the top shape small.

The first stroke of **R** is like **I** and **L** above.

STAGE 2: The Alphabet

CAPITAL LETTER STRUCTURES

The pen angles used for Rustic capital letters are different from those used for other hands, ranging from 45° to 80°. There is some twisting of the pen from the top to the bottom of letters. The diagonals, beginning at 50° and finishing at 45°, plus the large 45° foot serifs, create a strong contrast with the thin vertical strokes.

THE STRUCTURE	THE STROKES			THE GROUP

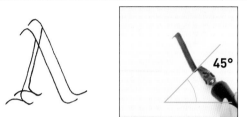

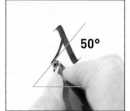

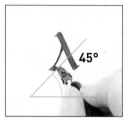

MVV WX

This group has heavy diagonals and serifs and very thin strokes. The letters should be fluid.

With a pen angle of 50°, pull diagonally to the base line, flattening the pen to 45° at the base.

At 60°, add the left diagonal, flattening the pen to 50° at the base line.

Add the serif, pulling downward, with a 45° pen, as a diagonal stroke.

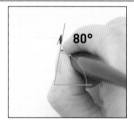

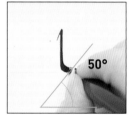

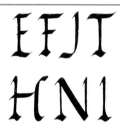

EFJT HN1

The steeply hooked top serif of the **L** rises slightly above the line. Other letters in the group do not.

With a pen angle of 80°, make a steep, upward hook serif, then pull downward.

Continue to the base line, flattening the pen to around 50°.

With the pen at 45°, add a serif, pulling the pen downward as a diagonal stroke.

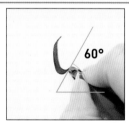

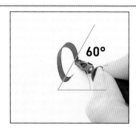

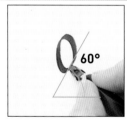

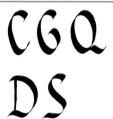

CGQ DS

These oval shapes require 60° pen angles. **S** and **D** are 50° at the top and 45° at the bottom.

With the pen at 60°, curve out and down, fairly straight, to the left, then curve at the base.

Overlap the thin stroke carefully at the top and curve upward, then down toward the base.

Continuing the shape, curve and overlap the thin stroke carefully.

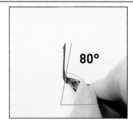

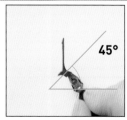

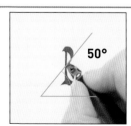

BRK YZ

In this group, top bowls are made in one 50° stroke, with 50° diagonals and heavy serifs.

Make a steep, hook serif at 80° and a vertical downstroke, as for **L**.

Change the pen angle to 45° to make the bottom serif.

Add the top bowl at a steeper 50° pen angle, creating the oval shape, joining the stem halfway.

THE ALHABET: CAPITAL LETTERS

The Rustic capital script has unusually thin vertical stems. Written at seven nib-widths high, it appears tall because most letters are only slightly wider than half the letter height. The letters **E**, **L**, **T**, **P**, and **F** are of minimal width. Movement is created by the changes of pen angle from top to bottom within the letter, the heavy diagonals—particularly on **A**, **N**, **M**, **U** and **W**—and the flamboyant serifs.

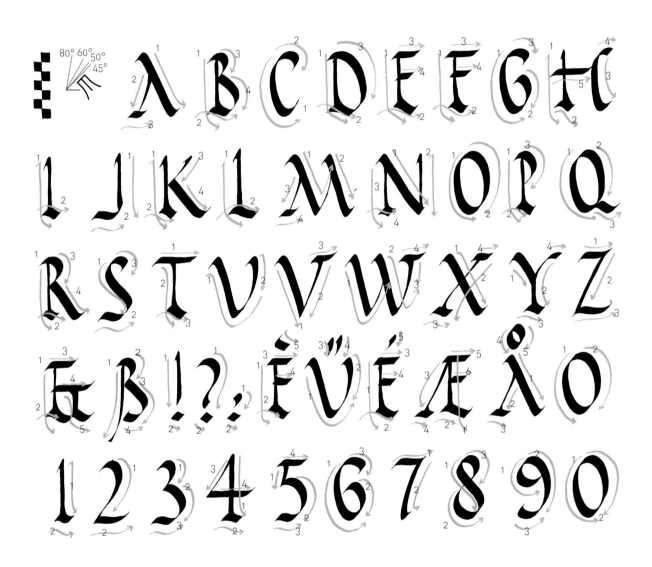

COMMON MISTAKES

Apart from adding a mistaken crossbar to **A**, the most common mistake is forgetting to hold the pen angle steep enough to make the thin vertical stems. Try not to make the letters too wide or too round as this destroys their elegance.

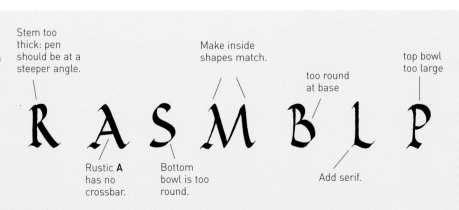

Stem too thick: pen should be at a steeper angle.

Make inside shapes match.

too round at base

top bowl too large

Rustic **A** has no crossbar.

Bottom bowl is too round.

Add serif.

PRACTICING FORMS AND SPACING

In historical manuscripts, Rustic hand was written without word spacing, creating very textural patterns of letter and space. Today, spaces are usually used in order to make the writing legible, although this is optional.

To retain Rustic characteristics as much as possible, spacing between words should be minimal and should appear even between letters.

LETTER SPACING

Good letter spacing
Spaces between and within letters should be visually equal to create an even texture. Spaces between words need only be fractionally bigger, just enough to make a difference.

Poor letter spacing
Wider and narrower spaces make this script difficult to read. The space inside **O** does not match the space between **O** and **D**, which gives the appearance of two words instead of one.

Good letter spacing
N and **U** are the widest letters here. The space between the two words is just a fraction bigger in order to create a break.

Poor letter spacing
The spacing is too wide, particularly the word space, making the letters look isolated. This diminishes the effect of the tall, narrow shape of the letters.

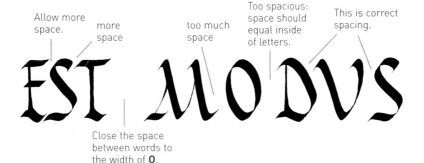

Allow more space.

more space

too much space

Too spacious: space should equal inside of letters.

This is correct spacing.

Close the space between words to the width of **O**.

less space

Close space between words.

fractionally less space

Close space fractionally.

Although this looks too close, it is correct.

WORD SPACING

In a longer piece of text, you can see how close and how narrow the writing appears, yet it is still easy to see the individual words, and the rhythmical texture is maintained. With Rustic capital letters, interlinear space is minimal: around three nib-widths, which is less than half the letter height.

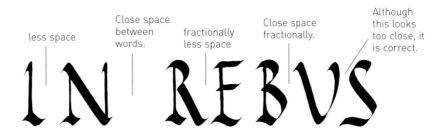

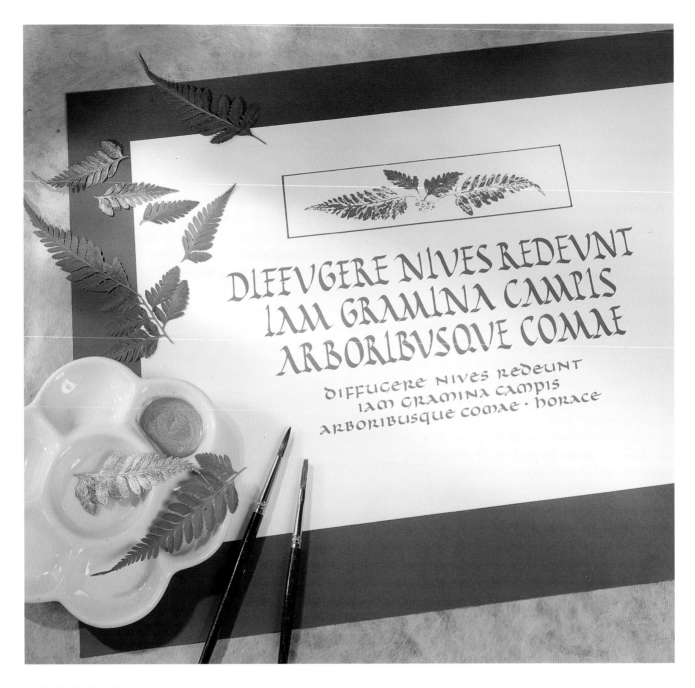

STAGE 3: Project

MAKING A BROADSHEET

A broadsheet that can be framed and hung on the wall needs much thought before its execution. Whether it will be simple or complex, you will need to decide if the shape of the finished work will be landscape or portrait style, whether or not color is appropriate, and whether or not illustrations will be incorporated into the design. You will then need to decide on a suitable text, letter form, color and size to convey the appropriate mood of your message or theme. This short quotation requires an uncomplicated layout with a simple leaf design. Always allow plenty of margin space around the work, otherwise it will look cramped and unbalanced. A suitable frame can add the final touch.

YOU WILL NEED

Pencil
Metal-edged ruler
Eraser
T square
Scissors
Craft knife
Paint palette
Dip pen and square-edge nibs (sizes 1½ and 3)
Layout paper
Watercolor paper, 90 lbs (190 gsm)
Tracing paper
Gouache paints
Leaves

1 THUMBNAIL SKETCHES
Make thumbnail sketches of your ideas before you begin. This will help with your layout and any decorative elements you may wish to add.

2 WRITING TRIALS
Experiment with different letter sizes and styles to find the most appropriate. This project uses Rustic hand and Uncial hand, which were historically used together. Experiment with color at the same time.

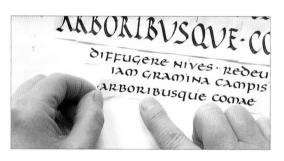

3 CUT AND PASTE
When the letter forms and spacings are correct, cut and paste the words onto a clean sheet of paper.

4 WRITING
Once you have made all your design decisions, write out the quotation on good quality paper. Make sure that all measurements and ruled lines are accurate. Place your practice sheet above or below your line of writing as a guide.

5 LEAF ARRANGEMENTS
Overlay your design with tracing paper and arrange your leaves into patterns.

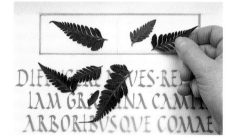

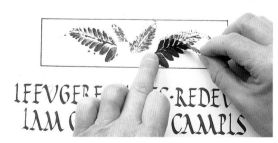

6 PAINT AND PRINT
Once you have completed the writing, you can add the leaf prints. Cover your writing with layout paper to protect it from any paint splashes. Draw the box with a ruling pen. Paint the underside of the leaf with gouache and press down on the paper. Repeat the leaf prints as necessary.

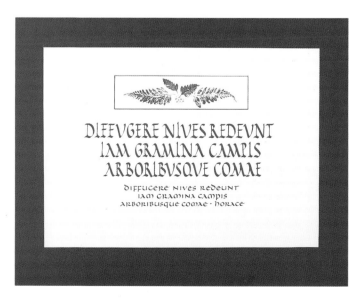

VARIATIONS ON THE HANDS

Now you have tried the different scripts and have become more familiar with the letter forms, you can begin to experiment and have some fun. Try breaking one of the rules. Breaking the nib-width rule can produce one of the most dramatic variations; try a big pen in a small space — the result will be heavy-weight writing. Conversely, a small pen in a big space will create thin, light lettering. Try changing the width of the letters, make them very wide or make them very narrow and compressed, give them heavy serifs or no serifs. The more you think about bending the rules, the more variations you will be able to devise. Remember to be analytical and consistent with your changed letter forms. The following are a few examples.

FOUNDATIONAL

abcdefg SERVARE MENTEM

Roman CAPS

UNCIAL

alpha beta alpha

Uncial written at
2½ nib height.

Uncial written at
6 nib height.

CAROLINGIAN

arduis Alpha

GOTHIC

ITALIC

 alpha beta

8 nib widths
'x' height.

alpha beta *alpha beta*

Italic compressed

FLOURISHED ITALIC

Alpha beta

7 nib widths
'x' height.

Alpha Beta

5 nib widths
'x' height with
pen pressure
and release.

BÂTARDE

modus

VERSAL

ALPHA BETA

Compressed and sloped

RUSTIC

 ALPHA BETA

Rustic hand written freely with a pen angle 45°-50°

GLOSSARY

Arch
The part of a lower case letter formed by a curve springing from the stem of the letter, as in h, m, and p.

Ascender
The rising stroke of a lower case letter.

Base line
Also called the writing line, this is the level on which a line of writing rests, giving a fixed reference for the relative heights of letters and the drop of the descenders.

Black letter
The term for the dense, angular writing of the gothic period.

Body height
The height of the basic form of a lower case letter, not including the extra length of ascenders or descenders.

Book hand
Any style of alphabet commonly used in book production before the age of printing.

Bowl
The part of a letter formed by curved strokes attaching to the main stem and enclosing a counter, as in R, P, a, and B.

Broadsheet
A design in calligraphy contained on a single sheet of paper, vellum or parchment.

Built-up letters
Letters formed by drawing rather than writing, or having modifications to the basic form of the structural pen strokes.

Carolingian hand
The first standard minuscule script, devised by Alcuin of York under the direction of the Emperor Charlmagne at the end of the eighth century.

Codex
A book made up of folded and/or bound leaves forming successive pages.

Colophon
An inscription at the end of a handwritten book giving details of the date, place, scribe's name or other such relevant information.

Counter
The space within a letter wholly or partially enclosed by the lines of the letter form, within the bowl of P, for example.

Cross-stroke
A horizontal stroke essential to the skeleton form of a letter, as in E, F, and T.

Cursive
The description of a handwriting form that is rapid and informal, where letters are fluidly formed and joined, without pen lifts.

Descender
The tail of a lower case letter that drops below the base line.

Flourish
An extended pen stroke or linear decoration used to embellish a basic letter form.

Gothic hand
A broad term embracing a number of different styles of writing, characteristically angular and heavy, of the late medieval period.

Hand
An alternative term for handwriting or script, meaning lettering written by hand.

Illumination
The decoration of a manuscript with gold leaf burnished to a high shine; the term is also used more broadly to describe decoration in gold and colors.

Indent
To leave space additional to the usual margin when beginning a line of writing, as in the opening of a paragraph.

Italic
Slanted forms of writing with curving letters based on an elliptical rather than circular model.

Layout
The basic plan of a two-dimensional design, showing spacing, organization of text, illustration and so on.

Logo
A word or combination of letters designed as a single unit, sometimes combined with a decorative or illustrative element; it may be used as a trademark, emblem or symbol.

Lower case
Typographic term for small letters as distinct from capitals, which are known in typography as upper case.

Majuscule
A capital letter.

Manuscript
A term used specifically for a book or document written by hand rather than printed.

Minuscule
A small or lower case letter.

Roman capitals
The formal alphabet of capital letters devised by the Romans which was the basis of most modern, western alphabet systems.

Rustic hand
An informal alphabet of capital letters used by the Romans, with letters elongated and rounded compared to the standard square Roman capitals.

Sans serif
A term denoting letters without serifs or finishing strokes.

Script
Another term for writing by hand, often used to imply a cursive style of writing.

Scriptorium
A writing room, particularly that of a medieval monastery in which formal manuscripts were produced.

Serif
An abbreviated pen stroke or device used to finish the main stroke of a letter form, a hairline or hook, for example.

Skeleton letter
The most basic form of a letter demonstrating its essential distinguishing characteristics.

Stem
The main vertical stroke in a letter form.

Uncial hand
A book hand used by the Romans and early Christians, typified by the heavy, squat form of the rounded O.

Versal hand
A large, decorative letter used to mark the opening of a line, paragraph or verse in a manuscript.

X height
Typographic term for body height.

INDEX

The translations for the latin quotes used throughout the book are as follows:

Aequam memento rebus in arduis servare mentem.

When things are steep, remember to stay level-headed.
Horace, 65-8 BC

Diffugere nives, redeunt iam gramina campis arboribusque comae.

The snows have dispersed, now grass returns to the fields and leaves to the trees.
Horace, 65-8 BC

Est modus in rebus.

Things have their due measure.
Horace, 65-8 BC

Nil desperandum.

Don't despair.
Horace, 65-8 BC

Omne tulit punctum qui miscuit utile dulci, lectorem delectando pariterque monendo.

He has gained every point who has mixed practicality with pleasure, by delighting the reader at the same time as instructing him.
Horace, 65-8 BC

Tempora mutantur, et nos mutamur in illis.

Times change, and we change with them.
Anonymous